GROLIER CLUB
BOOKPLATES

Grolier Club Bookplates Past & Present

ALEXANDER LAWRENCE AMES
&
MARK SAMUELS LASNER

WITH CONTRIBUTIONS BY
WILLIAM E. BUTLER & MOLLY E. DOTSON

NEW YORK
THE GROLIER CLUB
2023

The Eleanor Roosevelt section of Alexander Lawrence Ames's essay
was adapted and expanded from an earlier work by the author:
"Mrs. F.D.R.'s Bookplate: Eleanor Roosevelt, Dorothy Sturgis Harding,
and Designing a Bookplate Fit for a First Lady,"
The Bookplate Journal 15, no. 1 (Spring 2017): 46-53.

Title page vignette based on
the bookplate of Grolier Club founding member
Robert Hoe.

· ·

REGULAR EDITION
ISBN 978-1-60583-104-6

DELUXE EDITION
ISBN 978-1-60583-105-3

COPYRIGHT 2023 THE GROLIER CLUB

PRINTED IN THE CZECH REPUBLIC

CONTENTS

PREFACE 7

"REFINEMENT, TASTE, & BOOK CULTURE":
THE PLACE OF THE BOOKPLATE IN BOOK HISTORY
Alexander Lawrence Ames 11

BOOKPLATE COLLECTING & COMMISSIONING:
AN INTRODUCTION *William E. Butler* 33

THE CURIOSITY OF BOOKPLATE COLLECTING:
IRENE D. ANDREWS PACE, WITHIN AND
BEYOND THE BOOK *Molly E. Dotson* 45

BOOKPLATES OF PAST GROLIER CLUB MEMBERS 55

BOOKPLATES OF CURRENT GROLIER CLUB MEMBERS 103

NOTES 152

INDEX OF OWNERS, COLLECTORS, DESIGNERS &
PRINTERS 157

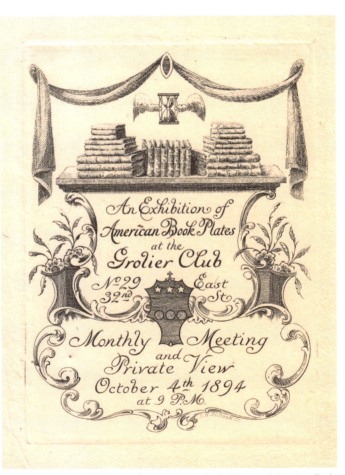

FIGURE 1. Stephen H. Horgan, Invitation to *An Exhibition of American Book-Plates at the Grolier Club*, engraving, 1894. (Grolier Club Archive)

PREFACE

The art of the bookplate is alive and well among Grolier Club members – just as it has been for more than 130 years.

The functional purpose of the bookplate is simple: collectors paste the small pieces of paper or leather into their volumes to identify ownership and establish a trail of provenance. Yet for centuries, bookplates have also served as visual testaments to book collectors' personalities, passions, and legacies. Ex-libris collecting and trading even emerged as a distinct bibliophilic enterprise, in line with bookplates' association with owners' personal traits and refinements, quite removed from bookplates' original marking purpose. Today, the ex-libris is a relatively obscure art form, its heyday in the United States having lasted from roughly 1880 to 1950. Bookplate design, printing, and use remain central to many book collectors' activities, however. The plates of past Grolier Club members rank among the finest examples of the art form, and many current members continue to commission and employ bookplates as part of their collecting practice. The *Grolier Club Bookplates, Past & Present* exhibition (November 2016–January 2017) showcased historic and contemporary bookplates alongside one another, to celebrate the continued vitality of the art form within and beyond the Grolier Club, and to encourage further exploration of the art form.

Bookplates are more than decorative embellishments. In many cases, thoughtful collectors worked closely with artists and printers to design fitting testaments to their individual interests. Knowing that their bookplates would likely remain pasted into their treasured volumes for years to come, collectors employed the ex-libris to establish their legacy among future owners and readers. The plates included in the *Grolier Club Bookplates* exhibition and this catalogue exude the character of their owners and the design savvy of their makers. Presenting dozens of examples of the ex-libris art form, each piece imbued with special meaning for maker, user, and viewer alike, *Grolier Club Bookplates, Past & Present* emphasizes the meaning behind the symbolism in the plates, and the legacy of the artists who bring patrons' dreams to fruition.

Grolier Club Bookplates, Past & Present commemorates the Club's long interest in the art of ex-libris. In October 1894, according to the *Transactions of the Grolier Club*, "the prevalent zeal for bookplates found expression in a very extensive display of Early American Bookplates." Officially titled "American Bookplates" although it included representative examples from Britain and France, this was the first bookplate exhibition held in America. The Club

simultaneously published *A Classified List of Early American Bookplates* by the curator, noted bibliophile Charles Dexter Allen.[1] (A delightful printed announcement of the 1894 exhibition, designed in bookplate fashion by Stephen H. Horgan, is reproduced here as Figure 1.) Eighty years later, in 1974, the Grolier Club's Committee on Modern Fine Printing sponsored an exhibition of members' bookplates. No catalogue was issued, and no full record of what was on view survives, but the Grolier archives contain correspondence from which we have quoted and derived information for this book. A number of members donated bookplates to the Club at the time as well; some of these are reproduced in *Grolier Club Bookplates, Past & Present*. It is fitting that, in the third century of its existence, the Grolier Club should offer a follow-up examination of the history and art of the bookplate in the form of this book, which draws on so many prior and current members' interest in the subject.

The publication has been long in the making. It began as a record of the 2016–2017 exhibition but has expanded to include the bookplates of Grolier Club members who joined after the exhibition's run, or who have since obtained bookplates. Scholarly and professional demands on the editors' time resulted in delays, as did the COVID-19 pandemic, which made access to the Grolier Club's collections difficult. Yet this pause also allowed for the development of additional commentary to accompany the original content. Included here are essays based on talks given at the Grolier Club symposium "The World of Bookplates" (January 11, 2017) by two Grolier Club members, Alexander Lawrence Ames and William E. Butler, and by Molly E. Dotson, formerly curator of Yale's bookplate collection, now in a new position at Princeton. We feel these contributions not only provide a useful introduction to the subject, but give what could be seen as a parochial publication a broader appeal to those interested in bookplates, printmaking, the history of collecting, and bibliophily.

A work of this kind must be a collaborative effort. Just soliciting, gathering, organizing, imaging, writing about, and keeping track of more than a hundred little pieces of paper (or, occasionally, pieces of leather) is a challenge no two persons could manage on their own. Our greatest thanks go to Meghan Constantinou, formerly the librarian of the Grolier Club, who has been a stalwart helper and friend from the moment the idea of the exhibition was proposed eight years ago, always finding solutions to endless complications and making the Club's substantial and growing bookplate collection available to us, even under lockdown. It was Jennifer Sheehan, exhibitions manager at the Grolier, who came up with the brilliant thought of mounting bookplates on colorful marbled paper backings, which made the exhibition on the second floor so visually successful. Assistant librarian Scott Ellwood

took on the time-consuming job of scanning the bookplates. Eric Holzenberg, director of the Grolier Club, and Chris Loker and Marie Oedel, successive chairs of the Committee on Publications, have always encouraged this project; our gratitude also goes to the members of the Committee on Modern Fine Printing, which sponsored the exhibition and has taken a role in helping fund this publication. Mark Samuels Lasner wishes to acknowledge the support of the University of Delaware Library, Museums and Press and the efforts of Danielle Canter and Olivia DeClark, graduate assistants in the Mark Samuels Lasner Collection. We thank Thomas G. Boss and Henry Raine for their generous assistance in several crucial matters. Jerry Kelly's wonderful design and typographical expertise on display in this volume speak for themselves. His support throughout this multifaceted project remains much appreciated. We also extend our warmest thanks to the Grolier Club members who participated in this project by contributing content to the exhibition, and especially to those who donated multiple copies of their ex-libris for inclusion in the special edition of this book. That our fellow Club members took time to write about their bookplates, and even share them with us and the world, makes this volume truly a community enterprise. We are grateful as well to the William Andrews Clark Library at UCLA, Harvard University Libraries, and the Rosenbach Museum & Library for donating copies of historic bookplates for inclusion in the special edition.

Finally, a word about the catalogue that forms the bulk of this book. The entries largely reprint the labels from the 2016–2017 exhibition and are divided into two sections: historical – that is, deceased members of the Grolier Club, and a few examples of the Club's own bookplates and related materials – and current – that is, living members of the Club. The texts about current members' bookplates derive from information received when original bookplates were donated for the exhibition; these texts were regularized at that time into a third-person voice. Notes and citations are omitted from the object labels. For a number of the more recent submissions, the editors have let the members' words stand on their own, placed within quotation marks. Every effort has been made to be as accurate as possible in the descriptions. The editors hope that *Grolier Club Bookplates, Past & Present* will inspire further dialogue, inquiry, analysis, and appreciation focused on the art of ex-libris.

Alexander Lawrence Ames
Associate Curator of the Rosenbach Museum & Library, Philadelphia

Mark Samuels Lasner
Senior Research Fellow, University of Delaware Library, Museums and Press

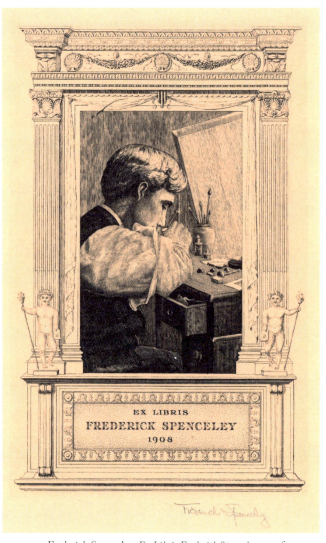

FIGURE 2. Frederick Spenceley, *Ex Libris Frederick Spenceley,* proof engraving, 1908. (Grolier Club Bookplate Collection)

"REFINEMENT, TASTE, & BOOK CULTURE": THE PLACE OF THE BOOKPLATE IN BOOK HISTORY

Alexander Lawrence Ames

∴

> Fashioning may suggest the achievement of a less tangible shape: a distinctive personality, a characteristic address to the world, a consistent mode of perceiving and behaving.
> — STEPHEN GREENBLATT, *Renaissance Self-Fashioning: From More to Shakespeare* (1980)

> As a sea shell holds / within its spiral form
> faint echoes of far / ocean spaces
> so may a bookplate oft / reveal in nuances of
> light and line / the owner's traits / and graces
> — BOOKPLATE OF MURIEL ALDERMAN

AN INTRIGUING, engraved self-portrait in the collection of the Grolier Club shows a young artist, facing away from the viewer, hard at work (Figure 2). Seen through an ornate, classical cartouche, and surrounded by tools of the artist's craft, the portrait's sitter and his environs convey dignity and seriousness of endeavor – an artist so consumed by his task that, even for his own portrait, he cannot steal a moment's glance in our direction. Sleeves rolled up, desk drawers ajar, brushes and tools strewn about – the scene we viewers have entered is one in which a studious artist pursues his muse. The artist? Frederick Spenceley (1877–1961). The muse? A bookplate.

It may prove challenging, at first, for those unacquainted with the rich history of the ex-libris to give bookplates their due attention, either as an art form or as a useful pathway for book-historical scholarship. In-depth bookplate analysis has remained relatively absent from cutting-edge work in the field. The subject may seem to many like a quarry of adust antiquaries and niche collectors. Yet bookplates are omnipresent. Researchers in special collections libraries regularly stumble upon bookplates in the volumes they study. Large gatherings of loose bookplates reside in repositories around the world. Bookplates can serve as important tools for unlocking histories of readership and studying bookish cultures across time. What is more, the art form, especially in the United States around the turn of the twentieth century, was taken up by passionate readers and collectors to fashion identities

within their bibliophilic spheres – a deliberate and detailed enterprise that allowed owners of books to construct a "self" through dialogue with the wider stylistic conventions of the book world, and by means of the functionalities and aesthetics of the bookplate genre. In our era when the social histories of reading and collecting rank as critical scholarly enterprises, these portraits of provenance deserve more than a passing glance.

Yet of what use are bookplates to the historian or literary scholar? Can they play any role beyond that of curiosity or sentimental collector's item? This essay proposes that Stephen Greenblatt's concept of "self-fashioning," which the renowned scholar first applied to authors of the English Renaissance, might serve as a unifying analytical principle for the study and interpretation of the bookplate by illuminating the role of the ex-libris in allowing readers and bibliophiles to fashion their identities within the world of books. Interpreted in this context, bookplates hold great value as historical evidence and contributed markedly to the social history of reading and collecting. Drawing on resources from the Grolier Club, the Rosenbach Museum & Library, the Free Library of Philadelphia Rare Book Department, the American Antiquarian Society, the University of Delaware Library, Houghton Library at Harvard University, and others, the essay forges a path for the incorporation of bookplate studies into the interdisciplinary study of the history of material culture. The essay begins with a summary of the tenets of Greenblatt's approach to self-fashioning before turning to two case studies of bookplate design: Dorothy Sturgis Harding's work on Eleanor Roosevelt's ex-libris, and Walter Crane's design of a bookplate for Harry Elkins Widener. As works of artistry, artifacts of printing technology, and primary sources of bibliophilic identity formation, bookplates illuminate otherwise dark corners of the republic of letters. They are portraits of prov-

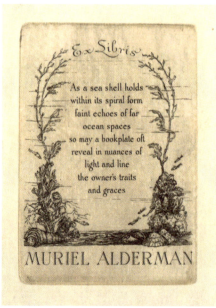

FIGURE 3. Margaret Ely Webb, *Ex Libris Muriel Alderman*, engraving, early twentieth century. (Rare Book Department, Free Library of Philadelphia)

enance. As Margaret Ely Webb inscribed in the bookplate she designed for Muriel Alderman, "As a sea shell holds / within its spiral form / faint echoes of far / ocean spaces / so may a bookplate oft / reveal in nuances of / light and line / the owner's traits / and graces" (Figure 3). It is telling that, in addition to a bookplate featuring this compelling aphorism, Muriel Alderman possessed another ex-libris that functioned as a portrait in a more conventional definition of the term. The whimsical verse quoted above captures the underlying principle of the art form: using the visual arts and the long tradition of marking one's books to craft a sense of belonging within the bookish world. Anyone interested in the history of books as artifacts and bibliophilia past and present has a vested interest in considering the bookplate's use as a tool for self-fashioning.

Self-Fashioning: Interpreting Bookplates through the Lenses of Identity and Self-Expression

With some notable exceptions, ex-libris studies have lacked a strong academic, theoretical framework to guide their incorporation into the wider world of book history and material texts.[2] This regrettable fact is perhaps due to bookplates' association with antiquarianism, the sometimes-feminized nature of ex-libris production (as will be discussed in relation to Eleanor Roosevelt's bookplate), or the "applied" nature of the ex-libris art form. Conceptualizing the bookplate as a wellspring of interdisciplinary, primary-source evidence about bookish identity formation and provenance is a useful path forward for narrating bookplates' full significance. Greenblatt's notion of self-fashioning, which examines the process by which individuals structure their identities within social frameworks, is a useful foundation on which to build a theoretical approach to bookplate studies. Fashioning, Greenblatt explains, is the creation of "a distinctive personality, a characteristic address to the world, a consistent mode of perceiving and behaving," yet one that is reliant on "the cultural system of meanings that creates specific individuals by governing the passage from abstract potential to concrete historical embodiment."[3] This negotiation between individual taste and cultural expectation is demonstrated in the process of creating bookplates – in which individual bibliophiles (with the help of skilled artists) fit their personal characteristics into established forms of communicating their status and taste to other collectors.

Bookplates, their makers, and their users operate in an economy of symbolism and exchange integrally tied to the republic of letters constructed by texts. This community included the books and manuscripts to which, in theory, the plates were intended to be appended but extended beyond the texts themselves – just as ex-libris design, collecting, and the exchange of

plates among collectors nourished social relationships within the bibliophilic realm. The artworks' symbological quality is a key part of their appeal. "Social actions are themselves always embedded in systems of public signification, always grasped, even by their makers, in acts of interpretation," Greenblatt writes in *Renaissance Self-Fashioning*.[4] "For Greenblatt," writes literary scholar Jan R. Veenstra, "author, text, reader, and society are not separate phenomena, but, on the contrary, they are inextricably intertwined, submerged, as it were, in one great continuum." Bookplates offer a unique window into the world of readership and bibliophilic identity by means of so many bibliophiles' active engagement with these conscious acts of self-fashioning.[5] While Greenblatt focuses primarily on written texts (i.e. symbolic goods) in his writings, the world of bookplate commissioning, collecting and trading lends a material, economic component to the crafting of a readerly identity within a "poetics of culture." Text on the letterpress bookplate used by Bell's Circulating Library in Philadelphia in the Revolutionary era, for example, reveals how the library sought to position its readers within a genteel literary and intellectual community while also keeping track of their physical property – that is, the books on loan to library members (Figure 4). The library was a place, according to the bookplate, "where sentimentalists, whether ladies or gentlemen, may become readers."[6]

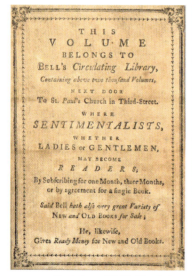
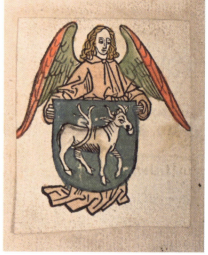

FIGURE 4. Bookplate of Bell's Circulating Library, Philadelphia, letterpress, ca. 1770. (Rare Book Department, Free Library of Philadelphia)

FIGURE 5. Armorial bookplate of Hilprand Brandenburg of Biberach, woodcut, ca. 1480, in Jacobus de Voragine, *Sermones quadragesimales*, manuscript, Bopfingen, Württemberg, 1408. (The Rosenbach, Philadelphia)

[14]

Early bookplates belonging to the European aristocracy often drew on the well-established art of heraldry as a natural means to mark one's library volumes; the oldest known surviving bookplate, belonging to Hilprand Brandenburg of Biberach, exemplifies this trend (Figure 5). Armorial bookplates remained common for centuries and constitute a form of self-expression bound up in dynasty and breeding. It did not take long, however, for makers and users of ex-libris to explore other strategies of identity formation. Greenblatt centers his study of self-fashioning on the Renaissance; not coincidentally, this period also saw creative self-fashioning by means of the art of ex-libris. A Renaissance era bookplate made in the workshop of Lucas Cranach the Younger shows Christoph Scheurl worshiping the crucified Christ, in keeping with Greenblatt's notion that religious devotion offered a prime strategy for self-fashioning (Figure 6). By the nineteenth and early twentieth centuries, placing an image of the reader in a bookish frame took on added importance in the art of ex-libris.

During a golden age of bookplate design in the United States around the turn of the twentieth century, traditional aesthetics established by the armorial bookplates of centuries past provided a template for a flowering of bookplate design, in which the bookish bourgeoisie enjoyed ultimate creativity in presenting themselves, their collecting interests, and their personal tastes in a dignified portrait of provenance. A small promotional pamphlet produced by Frederick Spenceley (whose bookplate appears in Figure 2) highlights the appeal of the ex-libris as a tool of personal expression.[7] "You

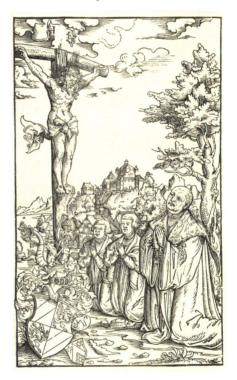

FIGURE 6. Lucas Cranach the Younger and Workshop, Bookplate of Christoph Scheurl, woodcut, sixteenth century. (Rogers Fund, 1921, accession number 21.35.14, Metropolitan Museum of Art, New York)

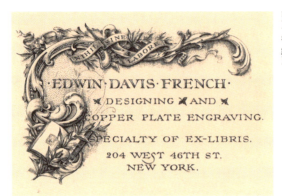

FIGURE 7. Edwin Davis French, *Nihil sine labore*, announcement card, engraving, 1896. (Grolier Club Bookplate Collection)

own books," the pamphlet declares. "Then you should own a bookplate." Spenceley's advertisement offers three reasons for this succinct assertion: the bookplate's practical use of identifying ownership of a particular volume, a sense of gentility that can be evoked with a bookplate's design, and the art form's personalized nature.[8] The Grolier Club's extensive collection of bookplates by Edwin Davis French (1851–1906, Grolier member 1899–1906), probably the most revered bookplate designer of the Gilded Age, reveals just how much personal expression his exclusive clientele could incorporate into their designs. The plates of bibliophiles like Mary Emma Plummer, John Page Woodbury (Grolier member 1887–1910), and Edward Duff Balken (Grolier member 1901–1939) all draw on the sumptuous accoutrements of an affluent person's library, as well as images of the ex-libris owner him- or herself, to evoke a distinctive bibliophilic aesthetic. Each plate is full of clues as to the collector's personality and interests – some obvious, some so subtle that their connotations are easily lost on the modern viewer.[9] Though his work was not limited to bookplates, the ex-libris was French's most notable activity and the realms in which he is best-remembered today – a point underscored by an advertisement for his workshop in the Grolier Club's collection (Figure 7).

French may have been the premier designer and engraver of bookplates for the American – and especially the New York – elite at the turn of the twentieth century, but he was far from the only artist to specialize in the genre. Bookplates by Elisha Brown Bird (1867–1943) in the Grolier's collection evoke the distracted subject of Frederick Spenceley's plate and showcase another popular motif during this period: that of the immersed reader ensconced in a chair in a library, looking away and keeping something of the physical self hidden (Figures 8 and 9). The conceit is that the

[16]

viewer has caught the bibliophile "in the act" – but at no loss, because the ex-libris itself is enough of a revelation to render a full visual exposure to the reader unnecessary. The ex-libris of Augusta LaMotte Brewer, a prominent bookplate collector, demonstrates the power of portraiture in the context of this art form. A photograph of the bibliophile closely resembles the bookplate that Margaret Ely Webb (1877–1965) created for her, though the ex-libris presents a more fanciful interpretation. In the ex-libris we see Brewer lost in the study and enjoyment of a collection of bookplates (Figure 10).

Clients of bookplate artists did not restrict themselves to portraits in their plates. Other forms of self-expression provided creative opportunities. A bookplate made by Edward Gordon Craig (1872–1966) for his mother, the famous actress Ellen Terry (1847–1928), did not include a likeness of her, but rather a much more practical image: a map indicating the location of Terry's home, should one of her books ever become lost and need to be returned (Figure 11). The bookplate of David Sulzberger (1838–1910), a leader of Philadelphia's Jewish community, envisages not the man himself but rather a pivotal moment in his life: the collision of two river boats. The example of the plate held by the Free Library of Philadel-

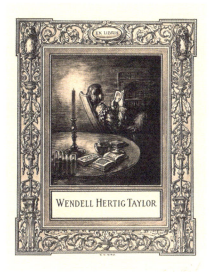
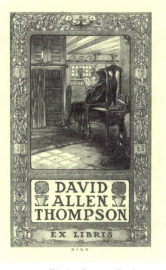

FIGURE 8. Elisha Brown Bird, *Ex Libris Wendell Hertig Taylor*, proof engraving, probably 1930s. (Grolier Club Bookplate Collection)

FIGURE 9. Elisha Brown Bird, *David Allen Thompson Ex Libris*, proof engraving, probably late 1890s. (Grolier Club Bookplate Collection)

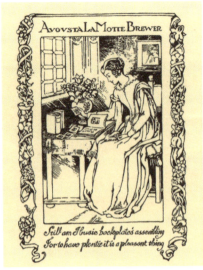
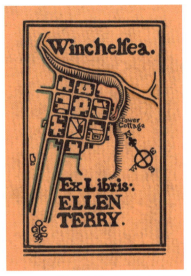

FIGURE 10. Margaret Ely Webb, *Augusta La-Motte Brewer*, engraving, ca. 1915. (William Augustus Brewer Bookplate Collection, Special Collections, University of Delaware Library, Museums and Press)

FIGURE 11. Edward Gordon Craig, *Winchelsea. Ex Libris: Ellen Terry*, woodcut, 1898. (Grolier Club Bookplate Collection)

phia Rare Book Department comes with a recounting of the story of the origin of the design, recalled by Sulzberger's fellow Philadelphian, Jacob Solis-Cohen:

> As a young man, David Sulzberger left Philadelphia to seek his fortune in St. Louis, Missouri where he was taken ill, I believe with malaria. He got on a river boat to go to New Orleans where there was a hospital and the boat had a collision in the fog with another boat and was sunk. He climbed out of his cabin, ill as he was, and got above the other boat and his life was saved. He came back to Philadelphia where he lived for his balance of a very long life.
>
> In 1936 I was the guest in England of Sir Thomas Colyer Fergusson . . . who has a very large collection of bookplates, and he told me he was waiting for 25 years to get some one [*sic*] from America,

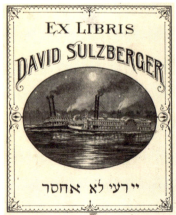

FIGURE 12. Unknown maker, *Ex Libris David Sulzberger*, engraving, late nineteenth century. (Rare Book Department, Free Library of Philadelphia)

[18]

particularly from Philadelphia who could tell him the significance of David Sulzberger's bookplate. It was very gratifying to me to be able to give him the explanation that I had received many years ago from Dr. Adler.[10]

The Hebrew on the bottom of the plate reads: "In God evil cannot take hold" (Figure 12). All these plates, even the most eccentric and unique among them, show a fealty to the basic formatting conventions of the genre – namely the inclusion of text announcing the name of the book collector, as well as the presentation of this text alongside a symbolic/representative image within a decorative frame. Such conventions made the artworks legible to other bibliophiles and ex-libris enthusiasts as vessels of personal bookish expression even though, as collectors' items in themselves, bookplates need not be attached to a book in order to fulfill their artistic and social role. The stylistic conventions epitomized in the sumptuous, Gilded Age designs of E. D. French proved rather versatile and were easily adapted to different tastes. The ex-libris of Frederick W. Skiff (1867–1947), for example, abides by the basic formatting conventions for a gentleman book collector's ex-libris of his era, but modified to suit the tastes of a passionate outdoorsman and collector of memorabilia connected to the settlement of the Northwestern United States. Appropriately, Skiff's plate, crafted in New Haven, Connecticut, in 1902, is found in an early volume of the statutes of Oregon Territory.

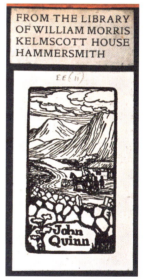

In keeping with their status as artifacts of self-fashioning, bookplates add personality, character, and the stories of individual readers and collectors to the volumes to which they are appended, placing physical objects within literary, intellectual, and print-culture contexts that enhance their significance. A copy of William Michael Rossetti's *Fine Art, Chiefly Contemporary* (1867) sitting on the shelves at the Rosenbach, for example, would be of interest simply as a first edition (Figure 13). Yet the presence on the front pastedown of the Kelmscott Press–printed book label of William Morris (1834–1896) and the bookplate of American lawyer and collector John Quinn (1870–1924), with whom Dr. Rosenbach had many notable dealings (including the acqui-

FIGURE 13. *From the Library of William Morris*, letterpress, 1896, and Jack Butler Yeats, *John Quinn*, wood engraving, 1904, in William Michael Rossetti, *Fine Art, Chiefly Contemporary* (1867). (The Rosenbach, Philadelphia)

[19]

sition of the manuscript of James Joyce's *Ulysses* at the sale of Quinn's library), dramatically enhance this copy's significance as an artifact of an epoch in artistic and cultural history. What is more, the Quinn bookplate was designed by Jack Butler Yeats (1871–1957), brother of William Butler Yeats, and itself comprises an historically valuable artwork. This record of provenance, contained entirely on the front pastedown of the book, places the volume at the center of an artistic network stretching from the Pre-Raphaelites to Modernists on both sides of the Atlantic, allowing Rosenbach interpretive staff who use it to showcase interconnections among the institution's collections. Likewise, the bookplate of Clement K. Shorter (1857–1926), designed by Walter Crane (1845–1915), can be found in the Rosenbach's copy of a pamphlet titled *The Polish Question: A Note on the Joint Protectorate of the Western Powers and Russia* by Joseph Conrad – privately issued by Shorter himself in 1919 (Figure 14). This important piece of political writing illuminates Shorter's role as the editor and founder of several popular magazines, opening up opportunities for discussion of his cultural world by means of the ex-libris. "Aesthetic response is therefore to be analyzed in terms of a dialectic relationship between text, reader, and their interaction," writes Wolfgang Iser, a seminal voice in the field of readership studies. "It is called aesthetic response because, although it is brought about by the text, it brings into play the imaginative and perceptive faculties of the reader, in order to make him adjust and even differentiate his own focus," Iser explains.[11] Bookplates help us put collectors and readers into conversation with the volumes to which portraits of provenance are affixed.

Bookplates need not have been commissioned works of art along the lines of E. D. French's elaborate baubles to indicate personality and link textual artifacts to broader social histories. Less intricate, commercially produced examples of the ex-libris hold the power to help scholars unearth histories of readership and book collecting among less affluent book lovers. Prominent Delaware librarian, educator, and civil rights activist Pauline Young (1900–1991) pasted her bookplate into volumes that had once been owned by her relation Alice Dunbar-Nelson, the Harlem Renaissance literary influencer, journalist, and teacher whose papers and library comprise one of the most important archival windows into the life and work of an African American woman in the late 1800s and early 1900s (Figure 15).[12] The presence of Young's ex-libris in such a book as Emmett J. Scott's *Official History of the American Negro in the World War* (1919), which also bears Dunbar-Nelson's signature, offers material evidence for the formation and preservation of this set of textual artifacts.

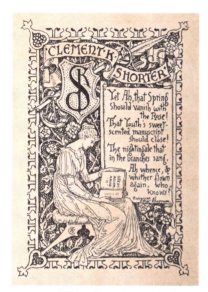 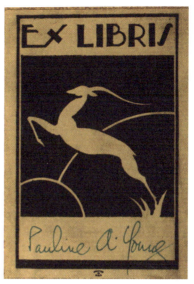

FIGURE 14. Walter Crane, *Clement K. Shorter*, in Joseph Conrad, *The Polish Question: A Note on the Joint Protectorate of the Western Powers and Russia* (1919). (The Rosenbach, Philadelphia)

FIGURE 15. *Ex Libris Pauline A. Young*, in Emmett J. (Emmett Jay) Scott, *Scott's Official History of the American Negro in the World War* (1919). (Special Collections, University of Delaware Library, Museums and Press)

Approximately ten percent of Dunbar-Nelson's books held today at the University of Delaware Library feature Young's bookplate – most of them highly important early works in African American history and literature. Why some volumes feature the ex-libris and others do not is unknown and open to speculation: Young may have engaged more deeply with some works from Dunbar-Nelson's library than with others. Possibly the volumes with the bookplate were gifted by Dunbar-Nelson to Young prior to Dunbar-Nelson's death, or perhaps Young actually read the volumes in which her ex-libris appears. Further research could be done to trace patterns in Young's marking practices. Whatever the case, signs of ownership allow for robust conversations about collecting and reader reception in this and other collections in which bookplates appear. The presence of the ex-libris of Arthur A. Schomburg (1874–1938), famed collector of African Americana now held at the New York Public Library, in Benjamin F. Hughes's 1833 work *Eulogium on the Life and Character of William Wilberforce, Esq.* illuminates this point. While other documentation exists to establish the book's ownership history, this bookplate reminds even the

[21]

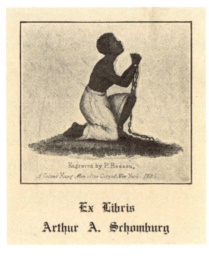

FIGURE 16. *Ex Libris Arthur A. Schomburg*, featuring reproduction of engraved print by P. Reason, in Benjamin F. Hughes, *Eulogium on the Life and Character of William Wilberforce, Esq. Delivered and Published at the Request of the People of Color of the City of New York, Twenty-second of October, 1833* (1833). (Schomburg Center for Research in Black Culture, Manuscripts, Archives and Rare Books Division, New York Public Library)

most casual reader of the volume's connection to Schomburg's life work via one of the most famous images of American abolitionism – clearly inculcating Schomburg's collecting interest (Figure 16).

Art(ists) of the Bookplate: The Eleanor Roosevelt Example

Thus far, this essay has offered a theoretical and methodological framework within which to interpret the art of ex-libris. It now turns to two case studies that showcase the power of bookplate studies to lend nuance, texture, and personal flavor to standard historical narratives. Eleanor Roosevelt, famed for her Civil Rights activism and advocacy for international relations, was also a bookplate user. The story of the design and production of Roosevelt's bookplate, and her cordial relationship with Dorothy Sturgis Harding, offers an intimate glimpse into the lives of the First Lady and the artist she patronized. It also sheds light on the notable role Roosevelt, Dorothy Sturgis Harding, and numerous other women have played in the vibrancy of the ex-libris art form. Caches of correspondence and preliminary designs at the Franklin Delano Roosevelt Presidential Library & Museum in Hyde Park, New York, and at the American Antiquarian Society in Worcester, Massachusetts, open this story to modern eyes and remind us of the power of bookplate artistry to bring historical personalities to life.

Daughter of the prominent Boston architect Richard Clipston Sturgis, bookplate artist Dorothy Sturgis Harding (1891–1978) came by her penchant for elegant design naturally. Her father was an accomplished draftsman and designed many buildings in the Northeast United States. Dorothy studied

at the Boston Museum of Fine Arts in 1910 and resided in Winchester and Portsmouth, New Hampshire, with her husband, Lester William Harding. Employed by the Portsmouth Naval Shipyard for fifteen years, beginning in 1942 – indicating the breadth of her career quite outside the book arts[13]– she crafted bookplates for many New Englanders and engaged with the wider bookplate and artistic communities of her time.[14]

The commission from Eleanor Roosevelt was of course the commission of a lifetime. Harding's final design for Roosevelt, completed in 1935, features motifs one would expect: An American eagle crowned with a diadem of six stars and flanked by two cherubs holds an arrow in each talon. It sits atop the Roosevelt family crest, consisting of three roses and the Latin motto "qui plantavit curabit," meaning "the one who planted it will take care of it." Ornate classical embellishments, including columns, an entablature, and a pediment, figure prominently on the piece. Roosevelt's name appears in a cartouche at the bottom of the plate, below which Harding signed and dated her elaborate yet whimsical work. One is amused to learn that, when Roosevelt initially engaged Harding, she requested a "very simple" design.[15]

Roosevelt approached Harding at least as early as 1933, when the First Lady, with characteristic modesty, told the artist that "I could not pay more than a hundred dollars, and would want a very simple book plate."[16] As things progressed, however, the plate became grander in aesthetic. (An early iteration of the plate shows a restrained design, with a circle of stars the most explicit reference to Roosevelt's national stature.) Following up on a conversation about bookplate design, Harding wrote to Roosevelt that "I am to make you a sketch of the idea we discussed . . . for a bookplate and bring it down to Washington to show you between Christmas and New Years. We agreed on a price of $100.00 for my design, which I hope you understood did not include the cost of printing."[17]

Harding paid a visit to the White House on December 31, 1934, summoned to Washington via Western Union telegram.[18] A little over two weeks later, she wrote to Roosevelt, describing the final form the bookplate would take. "Dear Mrs. Roosevelt," the letter began, "Confirming our conversation at the White House, Mon. Dec 31st '34 I am to finish your book-plate after the new sketch I showed you – a design with your coat of arms in the centre supported by decoration suggestive of wrought iron work."

> The plate, when finished, will be your property, but I will leave it with the Forbes Lithographic Co[mpany] of Boston, as is my custom, with your approval, so that you may order more prints from them at any time. I now wish only to know how many prints you want when they are first made. . . .
>
> May I also thank you most warmly for all your kindness & courtesy to me

FIGURE 17. Dorothy Sturgis Harding, *Ex Libris Eleanor Roosevelt*, photomechanical print, 1935. (Dorothy Sturgis Harding Bookplate Archive, American Antiquarian Society)

at the White House, it was an experience which needless to say I enjoyed tremendously, & I am most grateful. Very sincerely yours, Dorothy Sturgis Harding.[19]

Two working drafts created by Harding as she prepared Roosevelt's bookplate reveal details of the artist's creative method. The first shows several versions of the cartouche bearing Roosevelt's name that, along with the pillars that appears on the final bookplate (Figure 17).

Roosevelt had in the meantime written to Harding, asking how much it would cost for five hundred plates; Harding informed her that the price would total $10.00.[20] Shortly thereafter, on January 24, Roosevelt instructed Harding to order five hundred plates. Communications regarding paper type, color, and sizes continued through March. On March 21, 1935, Harding wrote to Roosevelt: "I hate to make any further delay on your book-plate, particularly as you were willing to leave the finishing to me, but the choice between the proofs . . . is so entirely a matter of personal preference, and I am so anxious that you should have just what you want," that she required further input before placing the final order.[21] With all details settled, on April 17, 1935, the Forbes Lithograph Manufacturing Company of Boston mailed Roosevelt's bookplates to the White House, along with, so the bill suggests, a framed copy of the print.[22] On April 26, Roosevelt wrote to Harding, "The book plates have arrived and I am very pleased with them. I am enclosing my check, and many thanks to you."[23]

Harding was anxious to share her design for the bookplate of such a prominent person with the artistic and collecting community. "Another question has just occurred to me which will undoubtedly arise in the course of time, and in regard to which I would like to know your wishes," Harding wrote to Roosevelt:

> Some years ago, at the suggestion of the president of the American Soc[iety] of Bookplate Collectors and Designers, I ceased to give away any of the prints of book-plates I have designed. They now sell to collectors for $1.00 a piece. I would, however, very much appreciate your permission to give one to the Metropolitan Museum in New York, & one to the British Museum, which latter, I may add will not accept it unless it is of sufficient artistic merit

– tho[ugh] they have accepted some of mine in the past. With regard to other requests for a print of your book-plate, if you are willing that I should pursue my customary policy in this matter, I would want to place a much higher price (probably $5.00 a piece) on prints of yours, as they will naturally be more valued by collectors, and should be made more rare. . . . I believe that book-plates of distinguished people sometimes bring very high prices. However, I wish to be governed entirely by your desires in this matter.[24]

"Please do as you wish about the bookplate," Roosevelt responded.[25] Later, Harding invited Roosevelt to join the American Society of Bookplate Collectors and Designers, though Roosevelt demurred. "I do not feel that I can affiliate with anything new at this time as I am already connected with so many groups and am so extremely busy," the First Lady explained in 1938.[26]

Correspondence between the two women was not limited to bookplates, nor did their interactions end in the 1930s. On June 7, 1958, Harding approached Roosevelt seeking permission to include the by-then former First Lady's ex-libris in a book of her designs, to which Roosevelt agreed.[27] "Of course I have no objection to your using the bookplate and it will not be necessary to let me see a copy of the chapter" in which the ex-libris was to be featured, Roosevelt wrote to Harding, from her home at 211 East 62nd Street in New York. Roosevelt added: "I would like to have some more book-plates and I wonder if you would be good enough to let me know the cost."[28] Informed that the bookplates would cost $8.00 per hundred, Roosevelt ordered another two hundred.[29] The surviving letters and bookplate designs exchanged between Eleanor Roosevelt and Dorothy Sturgis Harding thus document a several-decades-long relationship.

While their correspondence offers a frequently delightful window into the world of twentieth-century bookplate design, showcasing how a successful relationship between patron and artist could result in the fashioning of a bibliophilic identity by means of the ex-libris, it also reveals occupational and socioeconomic limitations placed on Americans in the 1930s and 1940s based at least partly on gender and circumstance. Letters exchanged between Roosevelt and Harding show that the latter, while an accomplished, well-known bookplate designer, held ambitions in the fields of architecture and engineering. (As mentioned, Harding's father was an acclaimed Boston architect, meaning that she likely aspired to follow in his footsteps.[30]) Harding applied for the position of "Assistant Engineering Draftsman," a federal civil service position, and sought to leverage her background in bookplate design. Deemed ineligible, Harding appealed to the First Lady for help. Roosevelt, living up to her reputation as an advocate for social justice, initiated inquiries, but to no avail.[31]

In a letter dated October 22, 1941, sent to the White House, Lawson A. Moyer, Executive Director and Chief Examiner of the United States Civil Service Commission, informed Roosevelt that he had reviewed Harding's case but stood by the decision. The shortcoming of her application, Moyer contended, was not in Harding's education, but in her professional experience. "Mrs. Harding does have the required high school education but she has not definitely established her elementary training by the successful completion of 400 hours of actual classroom work in a school specializing in drafting, or the study of architecture or engineering at a college or university of recognized standing," he reported, continuing:

> She does show study together with certain other courses in art work with her father. It is doubtful whether or not the requirement for elementary drafting has been fulfilled. However, it does not appear that further consideration of this point would serve any beneficial purpose since one year in the desired options cannot be found.[32]

Moyer made it clear that Harding's background in illustration did not amount to applicable experience for architectural work in the eyes of the Civil Service Commission. "Mrs. Harding has not shown that she has been actively engaged in engineering drafting work," he wrote. "In this connection her experience appears to have been concerned with the design and rendering of book-plates." Offering a verdict to the inquisitive First Lady, perhaps to forestall further investigations, he concluded, "Mrs. Harding's application together with the additional information she submitted have been reviewed by the Commission's Board of Appeals and Review, but because of the above facts it was not found possible to assign her eligibility for appointment to the position of Assistant Engineering Draftsman under Announcement No. U-28. I regret that I cannot furnish you more favorable information in reply to your inquiry in Mrs. Harding's behalf."[33] In a letter to Harding the following month (in which Roosevelt declined to commission Christmas cards), she commented: "I am so sorry also about the Civil Service ruling."[34]

Eleanor Roosevelt's bookplate is a monument to her remarkable life and to Dorothy Sturgis Harding's artistic talent and business skills. The ex-libris and its associated archival records speak to the relationship the two women developed by means of the bookplate, not to mention Harding's high standing the design world such that she could attract as a client one of the most famous women in the world and carry on correspondence with British aristocrats, museum administrators, and other noted artists including Norman Rockwell and Rockwell Kent.[35] Yet we also sense Harding's frustration, shaped at least in part by gender norms around educational op-

portunities and professional life in the first decades of the twentieth century. The exchange between Harding, Roosevelt, and Moyer is a reminder that, behind every bookplate, regardless of how fanciful or innocuous it may seem, stand historical actors with ambitions, goals, and life stories that shaped the artifacts we see today.

A Case Study in Self-Fashioning: Harry Elkins Widener, "An American Lycidas"

To repeat the questions posed at the beginning of this essay, what use are bookplates to the historian or literary scholar? Can they play any role beyond that of curiosity or sentimental collector's item? The ex-libris of Harry Elkins Widener, copies of which survive at the Rosenbach and elsewhere (most notably the Houghton Library and Widener Memorial Library at Harvard University) suggests that bookplates do indeed merit their place in the historical record. While the story of the young, doomed Widener and, by extension, his bookplate, is as extraordinary as it is tragic, the tale points to the utility of the ex-libris in lending texture, richness, and personal narrative to the study of the history of the book.

Harry Elkins Widener (1885–1912, Grolier member 1909–1912), scion of two socially prominent Philadelphia families and an heir to one of the city's largest fortunes, was already a precocious bibliophile when he made the acquaintance of fellow Philadelphian and up-and-coming bookseller Dr. A. S. W. Rosenbach around 1905.[36] Rosenbach quickly became the mentor of, and primary dealer to, the young Widener in support of his book collecting. (His mother, the radiant Eleanor Elkins Widener, encouraged her son and financed many of his early acquisitions.) Widener soon cultivated specialties in nineteenth-century British literature, with a focus on color-plate books, the illustrations of Cruikshank, Dickens, and Robert Louis Stevenson. Rosenbach arranged an introduction to London bookdealer Bernard Alfred Quaritch, and the burgeoning collector's activities were known on the other side of the Atlantic.

Harry Widener's bookplate reflects his interest in illustration, the importance he placed on the British visual and literary arts – and the lengths to which he went to forge a bookish identity during his short-lived collecting career. Widener worked with the famed artist and designer Walter Crane to create his ex-libris. A bound collection of letters and bookplate proofs sent by Crane to Widener, held today at Houghton Library, documents the process by which the bookplate came into existence "My dear Sir," Crane wrote to Widener on June 21, 1908, after having received Widener's commission. "I have completed the designs for the two book-plates you commissioned.

Shall I forward them to you?" before suggesting to Widener next steps in transforming his design into a printed product. "I know of a young engraver who I think could engrave the designs for you.... For a process block or photogravure plate you could not do better than go to Emery Walker.... I am, yours faithfully Walter Crane."[37] Widener promptly responded with approval for the design, and on June 23, Crane wrote the young collector: "My dear Sir, Many thanks for your letter [and] cheque duly received.... I am very glad that the design pleases you.... I took some pains that you might have good specimens of my work."[38] In his letters, Crane discussed various reproduction options available to Widener, who eventually worked with J. A. J. Wilcox to engrave the bookplate design for printing. The ex-libris depicts an elegant woman on shipboard (possibly Harry's mother?) gazing out of a porthole. "Many thanks for sending the proof of your Book-plates engraved after my design," Crane wrote Widener on Christmas Eve, 1908, delicately weaving in a hint of consternation with the final product. "It has been very carefully done & has a delicate effect, but it strikes me that in the process of translation the character of my work has been rather lost in some details," Crane charged. "The effect is much smoother & softer. Some, of course, may think this an improvement, but I miss my own system of line. The style of lettering too, has been altered, intentionally, I presume, since I used solid black letters with little contrast of think & thin." Nonetheless, Crane ended on an upbeat tone, assuring Widener that the client's tastes should reign supreme. "However, since it pleases you that is enough, & I am glad."[39] A comparison of Crane's design (Figure 18) and the Wilcox engraving (Figure 19) confirms Crane's observations. Unfortunately for the young Widener as well as his friend and mentor Rosenbach, the transatlantic connection commemorated in the pictorial design on Widener's bookplate exacted a disastrous price fewer than four years following the bookplate's completion. Indeed, in retrospect, the design of Widener's bookplate portended a remarkable tragedy – and the birth of a bibliophilic legend. The view of the North Atlantic depicted on Widener's ex-libris inadvertently portended his watery grave.

Following one of their European visits, George Widener, his valet, Eleanor Elkins Widener, her lady's maid, and Harry Elkins Widener boarded the *R.M.S. Titanic* for a return trip to the United States, a decision that cost the beloved boyish bibliophile his life. While Eleanor Widener and her maid survived, the others perished at sea; Harry's body was never recovered. Overcome with grief at the death of her adored son, Mrs. Widener devoted herself (and a large portion of her fortune) to the construction of the Harry Elkins Widener Memorial Library at Harvard. Rosenbach became a close confidante and source of comfort, helping process the pain of her loss through

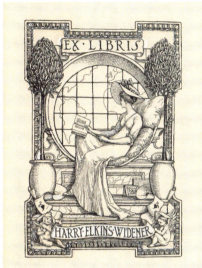

FIGURE 18. Walter Crane, *Ex Libris Harry Elkins Widener*, pencil and ink and paper, 1908. (Houghton Library, Harvard University)

FIGURE 19. J. A. J. Wilcox after Walter Crane, *Ex Libris Harry Elkins Widener*, proof engraving, 1908. (Houghton Library, Harvard University)

visits to the family's palatial Lynnewood Hall outside Philadelphia, playing a pivotal role in building out Harry's book collection (using Mrs. Widener's funds) as a tribute to a collecting career that might have been. "When the Library is finished I want all the books installed there – then I will feel happiness & know I have done as my dear boy wished," she wrote to him in 1915. "Over two years have gone since I lost him – & I am no more reconciled than I was at first – & never will be again. All joy of living left me on April 15 1912. Forgive me for writing you loved Harry & can understand my sorrow."[40] True to these sentiments, her son's collection resides to this day in the library she built – and her patronage helped launch Rosenbach's rise to become the premier antiquarian bookseller in the United States, if not the world.

Following Widener's death, tributes and reminiscences began populating the literature of book collecting and bibliophilia. The story of a collecting passion cut short became the stuff of legend. The Widener bookplate also grew in notoriety. A London *Daily Telegraph* article of June 5, 1912, while the Memorial Library at Harvard was under construction, referred to Harry Elkins Widener as "an American Lycidas" – drawing a parallel between Widener and Edward King, a friend of John Milton who had drowned, and whose death inspired Milton's memorial poem "Lycidas."

"The young bibliophile felt that his growing library deserved the dignity of a book-plate," the article read, "with the result that Mr. Walter Crane executed an appropriate design."[41] Five years later, in *The Amenities of Book Collecting* (1918), A. Edward Newton recalled (perhaps with embellishment) a conversation he had had with Widener not long before the young man's death. Harry seemed to foreshadow the events of his and his family's future by longing for attachment to a distinguished library. "I do not wish to be remembered merely as a collector of a few books, however fine they may be. I want to be remembered in connection with a great library, and I do not see how it is going to be brought about," Harry supposedly declared.[42] Newton mused over the memory: "I have often thought of this conversation since I, with the rest of the world, learned that his mother was prepared, in his memory, to erect the great building at Harvard which is his monument. His ambition has been achieved. Associated with books, his name will ever be. The great library at Harvard is his memorial. In its *sanctum sanctorum* his collection will find a fitting place."[43] Newton concluded his tribute with, what else, a reproduction of Widener's bookplate.[44] Newton was not alone in his embrace of the bookplate as an image of devotion to the martyred book lover. Rosenbach had published a limited edition volume in 1912 titled *In Memoriam: Harry Elkins Widener* that included Widener's bookplate as a frontispiece.[45] The documentation of the design of young Harry's ex-libris and the significance ascribed to the bookplate after its owner's death underscores Widener's successful effort to situate himself within the collecting world and fashion an identity within a larger bibliophilic context, lending texture and personal detail to the story of the life, achievement, and death of the young man and his lasting impact on book history.

 A unique Widener ex-libris functions as a memorial of sorts at the Rosenbach today in the form of the proof Harry inscribed to Philip Rosenbach, the brother and business partner of bookseller A. S. W. Rosenbach and manager of the firm's financial affairs. "To Mr. Philip H. Rosenbach in return for many kindnesses. Harry E. Widener," it reads. This occupies a special place in the Rosenbach's bookplate collection, evoking a pivotal relationship that shaped the trajectory of the brothers' business enterprise as well as the contours of their personal lives. To quote Dr. Rosenbach, "The name of Harry Elkins Widener will be recalled whenever books are mentioned; the building at Harvard shall stand as a monument to him; the library that he formed with such loving care and devotion shall remain, in accordance with his desire, forever at the service of the scholar and the student."[46]

Conclusion: An Invitation to Bookplate Study

As the artworks highlighted in this essay demonstrate, for many centuries the ex-libris has animated book lovers, inspired aesthetic achievement, and documented provenance in volumes found in libraries and private collections around the world. The concept of self-fashioning, famously and elegantly developed by Stephen Greenblatt in application to English Renaissance literary figures, provides one possible path forward for the critical interpretation of bookplates within a wider, theoretical book-historical context. Yet the goal of this essay has not been to prescribe a single approach to the subject, but rather to invite readers, scholars, and collectors to envision a more multifaceted role for the bookplate within the historical record. If a coterie of influencers and tastemakers as varied as Lucas Cranach the Younger, Augusta LaMotte Brewer, Edward Gordon Craig, Ellen Terry, Jack Butler Yeats, Dorothy Sturgis Harding, Eleanor Roosevelt, Arthur Schomburg, Harry Elkins Widener, Pauline Young, and the others discussed here found meaning and utility in the ex-libris, then rest assured, this genre of artistry pulsates with a revelatory power worthy of investigation, analysis, interpretation, and celebration. May this Grolier Club volume bring the art of the ex-libris to audiences old and new, and celebrate the place of the bookplate in the annals of book collecting, both past and present.

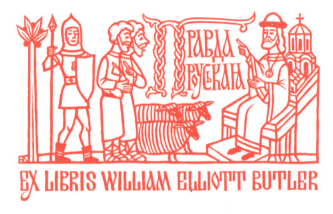

FIGURE 20. Jacques Hnizdovsky, *Ex Libris William Elliott Butler*, woodcut, 1985. The theme is the first Russian/Ukrainian Law Code, the *Russkaia Pravda*, depicting the Grand Prince of Kyiv deciding a dispute over sheep.

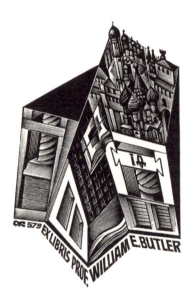

FIGURE 21. Anatolii I. Kalashnikov, *Ex Libris Prof. William E. Butler*, wood engraving, 1979. Showing the first Russian printer, Ivan Fedorov, whose initials appear on the printing press.

BOOKPLATE COLLECTING & COMMISSIONING: AN INTRODUCTION

William E. Butler

. .

The year 2022 marks the centenary of the American Society of Bookplate Collectors & Designers (known by the acronym ASfBC&D). That society was not the first in the United States to be formed by bookplate enthusiasts. When precisely Americans began to collect marks of ownership placed in books in all likelihood dates to early in the second half of the nineteenth century.

German collectors believe the pastime may date back to the second decade of the eighteenth century, based on the evidence of a surviving album of ephemera with some bookplates pasted in. English sources suggest collections were being formed there by at least the 1840s. In the United States, a few collectors were known by the 1860s, among them James Eddy Mauran (1817–1888), whose collection of ca. 4000 foreign and American bookplates must have been among the largest in the country and in due course became part of the H. E. Deats Collection.

Students of heraldry are well aware that bookplate designs from the earliest days used heraldic devices to identify owners and ownership. Even in democratic America, heraldry had its place. The *Heraldic Journal*, published in Boston, Massachusetts, from 1865 to 1868, made reference to American bookplate engravers and to the "Harris Collection" of bookplates. In his *The Elements of Heraldry*, William Henry Whitmore (1836–1900) illustrated bookplates and referred to American bookplate designers. The collector Richard C. Lichtenstein drew upon his holdings to produce ten articles on American bookplates in American and English antiquarian, bookplate, and heraldic journals, including *Curio*. The preeminent authority on the subject, Charles Dexter Allen (1865–1926, Grolier member 1894–1907), author of *American Book-Plates* (1894), estimated there may have been as few as twenty collectors throughout the United States in 1890.

Ex-Libris and Bookplates

Whatever were bookplate enthusiasts collecting? The terms "ex-libris" (sometimes hyphenated, sometimes not, both being correct) and "bookplate" overlap, but are not synonyms. The difference might be expressed

as follows: all bookplates are ex-libris, but not all ex-libris are bookplates. Ex-libris is the more general term for all marks of provenance indicating ownership of a book or manuscript. Most commonly they are deliberately placed on or in the book or manuscript for the specific purpose of designating ownership, and often take the form of a simple signature. Bookplates are a subspecies of ex-libris, usually but not necessarily on paper (examples are known on fabric, birch-bark, plastic, metal, leather, wood, and others). There are many sub-subspecies of bookplate – a subject to which ex-libris collectors have devoted learned articles on classification(s).

Origins of Provenance Marks

Marks of ownership in the form of the ex-libris go far back into human history – perhaps one may assume as far back as humans began to produce and own scrolls of written texts and the eventual invention of the codex. There are doubtless dissertations to be produced on the correlation of provenance marks and concepts of ownership and property in society. The origin of bookplates we associate with the advent of printing with moveable type in the second half of the fifteenth century. We have yet to do a proper study of ownership marks imposed by woodblock, seal, or other earlier means and devices for designating provenance. Collections of ex-libris will ordinarily commence with the incunabula of bookplates dating from the mid-fifteenth century.

Organized Bookplate Collecting

The first known society of bookplate collectors was established in London in spring 1891. Called the Ex Libris Society, it was the harbinger of a remarkable spontaneous movement in Europe and North America to encourage the scientific study of ex-libris and promote the commissioning and exchange of bookplates. Perhaps belying Allen's low estimate of American interest in bookplates, Americans joined the English society in significant numbers – more than fifty by 1894. By 1896 a small group of collectors in the Washington, D.C., area considered the moment to be opportune to found the Washington Ex Libris Society. A year later that Society assumed national significance and renamed itself the American Bookplate Society with a greatly enlarged list of officers. It published an official booklet, *Ex Libris*, in numbered ordinary paper and Japan vellum versions, 310 copies in all. Four issues appeared. A few brief months after going "national," the Society announced its liquidation for lack of sufficient support.

The British Ex Libris Society went from strength to strength, its example leading to imitators in Germany, France, Belgium, Holland, Italy, Russia, Scandinavia, Spain, Portugal, and elsewhere. In the United States, the

initiative passed to the West Coast, where Sheldon Cheney (1886–1980) – a student at the University of California, Berkeley – launched a small quarterly journal in November 1906, *California Book-Plates*, at his own expense and under his editorship. The California Book-Plate Society was founded on May 4, 1907; Cheney's journal became its official organ under a new name: *The Book-Plate Booklet*, publication continuing until 1911. The Society, however, lived on for another four decades, winding up at a final meeting in Palo Alto on September 15, 1950.

Back on the East Coast, a second American Bookplate Society was established on February 1, 1913, by eighteen charter members, mostly from New York City, but with a secretary-treasurer and editor of its official publications based in Kansas City, Missouri. This was Harry Alfred Fowler (1889–1959, Grolier member 1911–1926, 1937–1940, 1945–1950), whose enthusiasm and support were unstinting and contagious. Fowler had floated a trial balloon in 1911 by publishing *The Bookplate Booklet* and raising in its September issue the possibility of a national society. The following year he launched the *Ex-Libran* in larger format and on finer paper. It too was a transitional undertaking, and in its last issue he announced yet another publication, *Biblio*, superseded in 1914 by *Book-plate*, two issues of which appeared under the editorship, on behalf of the Society, of Clifford Nickels Carver (1890–1965). This was in turn replaced from 1914 to 1916 by *The Miscellany*. In 1915, and again in 1920, the Society published an attractive *Year Book*. All these publications, important as collecting landmarks and significant resource materials, are scarce on the market.

In retrospect, it is not easy to know what was driving Fowler in his publishing ventures: one after another appeared, short-lived, but attentively and imaginatively edited. Between 1917 and 1921, six issues of *Bookplate Booklet*, New Series, appeared. *The Bookplate Bulletin*, published in 1919, was superseded by *The Bookplate Chronicle* from January 1920 to April 1925. From 1921 to 1925, Fowler published five lavish large-format volumes of *The Bookplate Annual*, together with his own collateral publications. From 1916 until ca. 1925, the American Bookplate Society organized annual exhibitions of contemporary bookplates at the Avery Library, Columbia University, from time to time at the Grolier Club, and twice at the National Arts Club. By 1927, however, the Society was dormant. Two quite different organizations succeeded to its place.

In California, collectors formed the Bookplate Association International in 1925 to organize annual juried international exhibitions of bookplates from all over the world. Its name was the inspiration for the journal *Bookplate International* (1994–2004), published in England twice yearly by the present writer.

Although Californians were the guiding nucleus of the organization, honorary vice presidents were recruited throughout Europe and Asia. No other country systematically mounted exhibitions of this breadth and scale during the interwar period. Twelve exhibitions were held in all from 1925 to 1936 inclusive under the stewardship of Helen Wheeler Bassett (1856–1936) and Dr. Orra Eugene Monnetta (1873–1936). The Los Angeles Museum at Exposition Park or the Los Angeles Public Library were the usual exhibition venues.

Meanwhile, in June 1922, overlapping Fowler's ventures in Kansas City and the Bookplate Association International in California, twenty-six bookplate collectors and designers founded the American Society of Bookplate Collectors and Designers. The collectors included Carlyle Solomon Baer (1890–1969), and among the designers were Elisha Brown Bird (1867–1943), Sara B. Hill (1882–1963), and the Rev. Arthur H. Noll (1855–1930). Noll was elected the first president, succeeded the following year by Bird. Baer, the lifeblood of the Society, served as secretary-treasurer until 1942 and thereafter as the sole officer until his death. Audrey Spencer Arellanes (1920–2005) succeeded Baer, and she in turn chose James P. Keenan as her successor.

During the first year of operations, the American Society of Bookplate Collectors and Designers had attracted fifty-one individual members and twenty libraries. By 1972, on the fiftieth anniversary, individual membership numbered about one hundred, with forty-two institutions. Over the next half century, overall membership fluctuated from ca. 150 to 200, consistent with most major bookplate societies in the world.

In a large country whose membership is geographically dispersed, meetings of members are infrequent at best. The Society is held together by its publications. Baer understood this well and took responsibility for editing a superior *Year Book*, handsomely designed and printed, from 1922 to 1969, duly continued by Arellanes and Keenan. Fascinated by the literature on bookplates, Arellanes compiled the standard and indispensable bibliography of periodical literature on Anglo-American bookplates (1971), which she updated quarterly in *Bookplates in the News* from 1986 to the end of her life.

At present, the American Society of Bookplate Collectors and Designers issues its *Year Book*, a quarterly *Newsletter*, and occasional publications, most available in hard copy or electronic form. The Society website contains a "Library" of about fifty standard reference works available digitally, extensive illustrations of bookplates, and details on membership.

American collectors will find membership in the Bookplate Society, in London, the successor to the Ex Libris Society, outstanding value for the leading journal in the English language, their own quarterly *Newsletter*, regular auctions, and the reference works routinely published.

The American Society of Bookplate Collectors and Designers and the Bookplate Society are members of the International Federation of Bookplate Societies (known by its French acronym, FISAE). This organization was established informally in the late 1940s, has met regularly from 1952, and holds international congresses at two-year intervals at rotating sites (Boston in 2000 and San Francisco in 2022). FISAE, as a society of societies, has about forty-five members; its congresses attract from 200 to 800 attendees.

Commissioning a Bookplate

Collectors of bookplates often became such because they wanted their own personal bookplate(s) for their private library. Deciding what sort of bookplate or book label is appropriate for your own books is typically one of those matters over which one procrastinates. Does one prefer a pictorial design or a label? What should be depicted on the bookplate? Who could, or would, undertake the design (including the possibility of doing it oneself)? Once designed, who can print it? How much will the designing and printing cost? How many should be printed? How is it to be affixed to the book?

Some may have a mature idea of what they would prefer, but most will seek inspiration from other sources. An excellent place for ideas is a well-illustrated book on bookplates.[17] Together with visits to appropriate websites, such a book may help you decide what you want or at least what you do *not* want. Many people design their own, usually by pen-and-ink drawings, later reduced and reproduced graphically, or with computer-assisted design (CAD) – a word of caution, however. Computer-based bookplate designs are usually explicitly excluded from most bookplate-design competitions, despised by most collectors, and otherwise considered unworthy of a private library even though there are excellent electronic printers and papers available on the market.

The so-called universal bookplate is the easy way out but not very satisfactory to the serious bookperson. These are stationery items, acquired at our local bookshop or stationer, on which you insert your name below the words "ex-libris" or "From the books of," wet or lick the obverse side, and paste the same into your book. The design is commercial art, as a rule, not made especially for you, and decidedly lowbrow in the world of books. But a useful start for children . . .

You may decide to follow a course that dates back to the seventeenth century: visit a quality jeweler, stationer, or similar establishment or upmarket antiquarian bookdealer and commission a bookplate design through them. Leading firms will/should know to whom to turn, or maintain a "stable" of engravers and designers who might supply what you seek, although the

designer is likely to be anonymous and unknown to you. The American and English bookplate societies know active designers and can introduce you to possible candidates.

Or you can summon resolve and approach a professional graphic designer or engraver, or typographer, or calligrapher, or freelance artist to undertake a commission. If you personally are acquainted with an individual whose work you admire, the matter is straightforward. If not, consulting the sources and websites will introduce you to the work of contemporary designers and normally will provide contact details.

There are certain guidelines worth bearing in mind. As a rule, choose a graphic artist rather than a painter. Image is important, but so is the quality of lettering – and a bookplate design will almost always contain lettering or be exclusively lettering. If lettering on existing examples of a graphic designer's work is poor, or not to the standard of the pictorial element, one possibility is to have lettering added later by typography. Consider how many printed of the bookplate you will require. If you have a large private library and intend to have but one personal bookplate, the techniques of mezzotint or aquatint are not for you because the inherent limitations on the number of quality prints is unlikely to exceed 200 and more likely to be ca. 100. The designer will know the limitations. An engraving on boxwood, however, can produce thousands of images without discernible wear. The same is likely to be so of a typographic or calligraphic design.

Instruct the designer clearly and comprehensively as to size and subject-matter of what you have in mind. The design is for you personally and your library. In all respects it is an expression of you and the values and interests you attach to books, learning, and the pleasures of reading. Most designers will submit preparatory sketches for your consideration, perhaps several variants; others work directly on the block, plate, or computer screen and effectively produce a finished design immediately. Disappointment is likely when your instructions are incomplete or ambiguous and the end result is not of your liking. Especially be explicit as to precisely what lettering should appear – no misspellings or infelicities.

Also agree with the designer how many signed and unsigned prints (proofs) he or she is to provide and who will print them. In the case of etchings, copper engravings, mezzotints, mixed techniques, and the like, the designer is likely to undertake the editioning of the bookplate. Wood engravings, woodcuts, linocuts, engravings on plastic or plexiglass, and the like can be printed in large quantities by a printer, although the designer will usually be willing to supply up to fifty or seventy-five artist's proofs. When the designer is not able to undertake the printing, or that is not fea-

sible, a printer will be recommended who knows the designer's work and can produce sympathetic impressions of quality.

The designer will most likely wish to retain a certain number of prints for his or her personal archive and for the purposes of exhibition, illustration, exchange, or even sale. Intellectual property rights will depend on the legal systems of the designer and client, but in most cases the rights remain with the designer unless expressly transferred to the owner of the bookplate. It is accepted convention in bookplate circles that the owner and the designer may exhibit and illustrate the bookplate, and that bookplate media will expect to do the same. It will be expected that the moral rights of the bookplate designer to be so identified will be respected.

There are certain canons of taste with respect to the wording or text on a bookplate or book label: the Latin words "ex libris," "ex bibliothecae," "from the library of," "from the collection of," "his book," "her book," "their book," and analogous formulas. But these words or phrases are not mandatory. Simply the name, or the initials, or other means (heraldic device) of identifying the owner often appear. When, however, classic wordings are used, they should be correct and not abbreviated. Thus, "EL" and "ExL" are in poor taste, mostly because they are not acceptable abbreviations of the Latin. Some feel strongly about whether it should be "Ex llibris," "ex libris," "Ex Llibris," or "exlibris," with or without a hyphen. Other languages are possible.

Modern bookplates sometimes are designed to be a miniature graphic rather than an obvious ex-libris and, indeed, collected with that in view. Often any wording or indication of the bookplate owner is deliberately buried in or integrated unobtrusively into the design so that literally a microscope is required to discover for whom the bookplate was designed. On this point there is no unanimity of view in the world of bookplates. The lettering, of whatever size and style, should be executed as carefully and skillfully as the design itself. The conviction is so widely shared in bookplate circles that the true worth of a designer is to be measured by the quality of the lettering more than by the pictorial image on the design. But tastes and requirements vary.

Ex-libris come in all shapes and sizes, as do books themselves – from elephant folios to miniatures. Large books are capable of accommodating a very large bookplate, and some indeed occupy an A4-size paper. To the extent that bookplates are designed as small-size graphics for exhibition and exchange, their dimensions are likely to be substantial. Miniature books, on the other hand, can assume literally microscopic proportions, so tiny that micro-bookplates have been designed for them. Most bibliophiles are likely to prefer their bookplate or book label to be ca. 2 × 3 inches.

Should a book collector be content with a single bookplate for his or her

collection: one fits all? There can be no categorical answer; it depends on the individual, the nature of the library, the various collections within the library, and the purposes of having a bookplate besides pasting it inside books. Many bibliophiles do have multiple bookplates – they enjoy supporting designers; they collect in various fields, each of which deserves its own bookplate; over time their means and interests have matured; they exchange bookplates with others. An alternative is to have a single bookplate in different colors and/or dimensions. But these are bibliophiles. Bookplate collectors – ex-librists – are certain to have multiple bookplates in their name for exchange purposes. One Italian collector had more than 2,500 personal bookplates for exchange.

Commissioning a bookplate inevitably engages the question of cost. This will depend upon the designer's fee and the costs of editioning or printing the bookplate. Each designer will quote his or her fee, and that should be settled when the bookplate design is formally commissioned by exchange of correspondence or even a formal contract. One may expect anything from $90.00 upwards, ranging from computer-aided design at the bottom of the scale to etching, mezzotint, or copper engraving at the top. Fees will also reflect the stature of the designer in the marketplace, or perhaps the volume of work on hand as the commission comes in, or the deadline imposed by the client.

Little has changed over time in the basic scheme of things. A simple typographic label or computer-aided design should be inexpensive, followed by linocut or engraving on plastic or other synthetic material, followed by engraving on or cutting of wood, after which comes engraving or etching on copper, steel, or similar surface(s). In between are a vast variety of other mediums – silkscreen, katazome, photo-collage – which are dependent entirely upon the designer. The use of color will ordinarily increase the price. Choice of paper is important, and the advice of the designer and/or printer should be followed. The paper needs to complement the image or design of the bookplate and be suitable for pasting in books. Gummed paper is usually unsatisfactory because it curls and sticks; ungummed paper will require you to work with flour paste or similar substance, ideally of archival quality. The best quality of appropriate paper will more than repay its cost. Margins are important to the visual impression which the bookplate makes in the book. If there is a plate impression mark around the edge of the image, any trimming of the bookplate should, at a minimum, be outside that mark.

Forming a Bookplate Collection

No one knows how many bookplate collectors there are – well into five figures is the likely number. The more than forty bookplate societies in the world have a combined membership in the high four figures.

How does an individual begin to form a collection? Each collector will have his or her own story to tell – and some are known to have begun as early as the age of seven – but stripped to fundamentals there are only a few basic ways of acquiring bookplates: by purchase, inheritance, gift, serendipitous find, or exchange. Most ex-librists have an interest in books and/or the graphic arts. A few dealers routinely stock bookplates; antiquarian bookdealers sometimes acquire a collection for sale, and they appear at auction from time to time. Bookplate society journals and newsletters carry announcements of collections available by private treaty. Some societies have regular auctions (the Bookplate Society in London; the Swedish bookplate society) open to members only. Bookplate collectors build their collections also by exchanging their personal bookplates and/or duplicate bookplates with other collectors by post or at national or international bookplate society congresses.

The tenets of keeping a bookplate collection are long established and complied with by most collectors. As a rule, bookplates are mounted on an appropriate card or paper of uniform size(s), sometimes specially printed for this purpose, and bearing the collector's name or space for entering other data. Some collectors use paper colors as a form of coding, ideally acid-free paper in these conservation-conscious times. Bookplates are usually affixed by a light flour paste applied in the two upper corners or by an appropriate archivally recommended hinge. Some collectors routinely scan their holdings and effectively catalogue their holdings online.

Within the collection, bookplates are organized, unless there are special reasons to do otherwise, by country and designer, and when the designer is unknown or anonymous, alphabetically by name of owner. Many collectors separate into different categories: institutional bookplates (public libraries, clubs, societies, subscription libraries, ships, etc.); or special types of bookplate design (bookpiles, armorials, pictorials, calligraphic, book labels, book-stamps, super-libri); or anything else they wish to treat specially.

The collector should annotate his or her bookplates with care. On the obverse side of each bookplate (including those personal bookplates exchanged with others), the name and country of the designer should be specified in light pencil (never ink), the year in which the bookplate was designed and printed, and the technique. FISAE has approved a list of standard symbols that all collectors know from memory as a convenient shorthand for designating bookplate design techniques. Where additional information is available, it may also be written on the obverse of the bookplate or on the bookplate mount: provenance, biographical data on the owner or designer; explanation of the design; references to published data on the bookplate or the owner; and any special information about the

bookplate. Copying this material into an online catalogue of the collection is admirable, but no substitute for having the data available on the bookplate obverse itself.

Joining Bookplate Societies

Every bibliophile ought to join a bookplate society or two whether an ex-librist or not. Provenance is so embedded an element of bibliophily that one really cannot do without some awareness of our past and what is going on in the present.

In the United States, the American Society of Bookplate Collectors and Designers is the national society. Formal meetings are not feasible given the vastness of the country, but members receive the quarterly *Newsletter* and the *Year Book*. The newsletter contains information about bookplates (usually recently designed ones), new and established designers, bookplate identifications and discoveries, exhibitions, owners and artists, recent publications, and notices of bibliographical data about other bookplate publications from around the world.

Ex-librists commonly join several societies around the globe. The Bookplate Society in England has many American members. It has published a proper journal, the *Bookplate Journal*, twice yearly since 1983, and publishes a quarterly *Newsletter* and an annual book included with membership. It holds quarterly auctions of an exceedingly high standard. Measured by standards of provenance scholarship, the Bookplate Society is the gold standard and highly recommended.

European societies whose journals, bulletins, and yearbooks are not published in the English language commonly carry English-language summaries of their contents. And the illustrations themselves are often sufficient for many collectors.

Bookplate Literature

Knowledge is the key to effective bookplate collecting and provenance studies. All ex-librists perforce become collectors of books, catalogues, articles, notices, and ephemera about individual bookplates, exhibitions, designers, and anything else of relevance. The reason is simple. All bookplate collectors make discoveries: they identify designers previously unknown; they find variants of ex-libris never before identified; they loan from their collections to exhibitions or provide illustration in publications, more often than not organizing exhibitions or bookplate design competitions. Bookplates are not like postage stamps. There is no exhaustive catalogue of all bookplates in the world; there is no such thing as "completeness" in bookplate collec-

tions, or even for individual designers. The ex-librist is dependent on a body of literature most diverse in origin, but a significant portion emanates from bookplate societies over the past thirteen or so decades. Most institutional libraries have but a small assemblage of such material; individual ex-librists have had to form personal reference collections, some exceeding 50,000 items *about* bookplates. A comprehensive bibliography would exceed several times that figure in number of entries. All this material contributes to provenance scholarship, to book history in general, and specifically to studies of art, design, library-formation, book collecting, and the book trade.

The high points of American bookplate reference works are illuminated elsewhere.[48] Two standard sources nonetheless deserve mention. The first is Aubrey Spencer Arellanes's *Bookplates: A Selective Annotated Bibliography of the Periodical Literature* (1971), which may be "selective" but is remarkable for its comprehensiveness. Arellanes updated the material for the years 1970–1995 in *Bookplate International* but did not succeed in completing a revised edition.

The second work is an extraordinary series of three massive multivolume projects conceived of, and executed by, Artur Mário da Mota Miranda (1928–2018) in Portugal. The first of these appeared under the title *Artisti dell' Exlibris/Artistas de Ex-Libris* (1968). It set the parameters Miranda more or less followed throughout his publishing: emphasis on the designers, concise biographical sketches (either in the subject or by a third-person volunteer), and copious illustrations, with tipped-in original bookplates, usually at least one per artist and often more. Seven volumes appeared in all, the last in 1982. This was followed by *Ex-Libris – Encyclopedia Bio-Bibliographical of the Art of the Contemporary Ex-Libris* (with parallel titles in French, German, and Spanish). This was larger in format with greater and fully exploited possibilities for illustration and/or tip-ins, biographical or autobiographical essays more substantial in scope, checklists of bookplates (almost always supplied by the designer and therefore reasonably complete), contact details (enabling readers to commission bookplates), and usually a photograph of the designer. Thirty volumes appeared between 1985 and 2003. A brief interval of "retirement" followed, but not for long. Miranda produced a third encyclopedia, *Contemporary International Ex-Libris Artists*, twenty-four volumes in all issued between 2005 and 2018. For all three publications the Australian ex-librist Andrew Peake published a thorough collective *Index* (2020). Taken together, there is no better single guide to contemporary ex-libris design and designers for the past half century. Finally, in Austria, Dr. Karl F. Stock is producing a remarkable series of country and thematic bibliographies of ex-libris literature; they are available in print and digital.

MRS. IRENE D. ANDREWS
MRS. EDMUND ANDREWS
MRS. IRENE D. PACE
MRS. ERNEST M. PACE

Are one and the same person. Please address all bookplate correspondence to
MRS. EDMUND ANDREWS
as she exchanges and collects only in that name.

FIGURE 22. Mrs. Edmund Andrews exchange card, undated. (Andrews Memorial Bookplate Collection of Irene D. Andrews Pace, Robert B. Haas Family Arts Library, Yale University)

THE CURIOSITY OF BOOKPLATE COLLECTING: IRENE D. ANDREWS PACE, WITHIN AND BEYOND THE BOOK

Molly E. Dotson

. .

> How collections are accumulated is sometimes of more human interest than a description in words of items. . . . So it is with bookplates.
> —WARREN HIRAM LOWENHAUPT

Introduction

BETWEEN 1924 AND 1961, Irene Greene Dwen Andrews Pace (1893–1962) commissioned nearly 100 artists to design nearly 300 personal ex-libris.[49] These myriad designs represent as many as fifteen name variations for Pace, or Mrs. Edmund Andrews, as she preferred to be addressed when conducting bookplate exchanges (see Figure 22). By deploying this corpus of personal ex-libris (and other resources), Pace amassed a collection of at least 150,000 individual bookplates, plus supplemental materials, all of which now constitute one of the cornerstones of the Yale Bookplate Collection.

The bookplate has, however, traditionally been relegated to the realm of biblio-esoterica. Its utility and seeming uniformity of purpose as well as its diminutive size may account for the lack of critical attention. If not already obscured by the flyleaf or otherwise ignored as mere decoration, a bookplate is rarely considered beyond its customary paratextual context – most often pasted on the inside front cover of a book.[50] Here a bookplate has a very particular function within the signifying system of the book. Through various means of word, image, or both, a bookplate indicates either a past or present owner of a (unique copy of a) book. As such, the bookplate is not merely a means of identification but a self-conscious record of the ownership of a particular book and often an indication of that book's membership among a specific set of books or library. And yet, many bookplates have never been and will never be affixed to a book.

This essay explores one of the fundamental curiosities of bookplate collecting – namely, giving away that which is a mark of personal possession. Ostensibly, this collecting practice nullifies the original purpose of the bookplate. What, then, is a bookplate that no longer serves as evidence of provenance or security measure (or act of vandalism, according to some book collectors)?[51] Is it a work of art, an act of vanity, or some other kind

of authorship?[52] By examining one woman's bookplate collecting, with a particular focus on her extensive personal ex-libris, I invite further consideration of the material and cultural significance of bookplates beyond the book. Here bookplates become independent works of art prized for their graphic variety and ease of collectability. They remain, however, embedded with individual identities as well as broader patterns of behavior and belief.

"Any bookplate is welcome"

The Yale Bookplate Collection is a unique visual archive that reveals a timeline of the history and the art of the ex-libris. Its holdings date from the late fifteenth to the twenty-first centuries, represent countries around the globe, and include specimens of varying size, theme, style, and medium. It comprises many discrete collections and thus reflects a diversity of collecting interests and practices that have developed around the ex-libris.

Yale is one of many libraries that acquired significant bookplate collections during or immediately following the height of bookplate collecting's popularity at the turn of the twentieth century.[53] When a census of library-held bookplate collections was published in 1938, Yale's collection of some 5,000 plates was noted as "growing for years without any particular effort to enlarge it."[54] Since then, numerous donors, collectors, artists, dealers, curators, and other Yale University affiliates have contributed to what is now a bookplate collection of staggering size (an estimated one million specimens un-affixed to books) and significant research value.

While still growing to this day, the Yale Bookplate Collection reached a critical mass primarily through the efforts of Warren Hiram Lowenhaupt (1891–1967, Grolier member 1961–1967).[55] Lowenhaupt was curator of bookplates and research associate at the Yale University Library from 1952 until 1960 and then an honorary trustee of the library from 1961 until 1967. He was not only a curator but also a notable private collector of bookplates (and other artworks). He increased both the breadth and depth of Yale's collection by donating the Pearson-Lowenhaupt Collection of English and American Bookplates, containing approximately 100,000 individual ex-libris.[56] As curator, Lowenhaupt traveled extensively, attending international ex-libris congresses and developing close relationships with bookplate artists and collectors.[57] He actively acquired individual bookplates as well as collections en bloc.

In 1955, Lowenhaupt wrote: "We hope that each friend of the Library will become bookplate conscious and send us his or her own plates or those of others which have been discovered. This applies to individuals and to associations, public and private, of all kinds. Any bookplate is welcome."[58] Arguably, Lowenhaupt's curatorial philosophy reflects the mentality of a competitive collector.[59]

Of course, one of the many bookplate acquisitions Lowenhaupt welcomed at Yale was the sizable collection of Irene D. Andrews Pace. Lowenhaupt and Pace were already acquainted, having exchanged bookplates as private collectors. Pace donated "some fine gifts" to Lowenhaupt's personal collection, and she had received from Lowenhaupt, for example, a Linonian Society bookplate designed by Amos Doolittle (1754–1832).[60] A memorandum written in 1954 to Lowenhaupt from James T. Babb (1899–1968), then university librarian, commends Lowenhaupt as a curator and acknowledges Pace as a potential donor: "You are certainly making some important acquisitions for our collection, and I do wish you the best of luck with Mrs. Pace."[61]

Under the stewardship of Lowenhaupt and her widower, Rear Admiral Ernest Milton Pace, Jr. (1891–1969), Pace bequeathed some 150,000 individual bookplates, plus correspondence, process materials, reference books, and other archival and published items related to bookplates. Pace's collection was given to Yale upon her death in 1962 as a memorial to her late first husband, Dr. Edmund Andrews (1892–1941, Yale Class of 1913), and his father, Dr. E. Wyllys Andrews (1856–1927).

Bookplate Consciousness

In many ways, Pace could be considered a model collector for Lowenhaupt's so-called bookplate consciousness. His framework places the emphasis on the act of exchange – that is, to "become bookplate conscious and *send* us his or her own plates."[62] Pace not only sent her numerous personal ex-libris out into the world, but she also carefully documented the discoveries that accompanied her commissions. In the end, however, she was in pursuit of a different kind of exchange, something more profound than a simple trade.

Pace first became bookplate conscious after a friend gave her a "handful" of bookplates in the early 1920s, toward the end of the heyday of bookplate collecting, which peaked in the early twentieth century. Pace had been an avid book collector since childhood, beginning while she was at school in Ireland.[63] But her fascination with bookplates transformed into lifelong fervor, and her handful soon multiplied by the thousands.[64] Like many others, Pace took advantage of the small size of bookplates to conduct much of her collecting by post, trading duplicates from her holdings but most often her own ex-libris designs. Shortly after acquiring her first bookplates, Pace began commissioning a portfolio of personal ex-libris.

Although Pace fully embraced the bookplate, she always maintained an extensive personal and reference library. Whenever possible, she researched the patrons, artists, and provenance of her bookplate acquisitions, and she often copied citations and quotes from reference materials alongside the

bookplates. These sheets with mounted bookplates were housed in three-ring binders. Pace then used these binders as scrapbooks, interfiling correspondence, clippings, and any other related materials. She also treated her books, which included between 500 and 600 titles on the topic of bookplates or specific artists, much the same way as the binders of bookplates. Her books often contained laid-in notes, correspondence with the author or a book dealer, or other bits of personal ephemera. In practice, her library became an extension of her bookplate collection.

Of course, Pace still affixed her own bookplates to the volumes in her library, but she kept an exceptional number of prints in reserve exclusively for bookplate exchanges.[65] In 1948, for example, Pace initiated an exchange with the Dutch artist Wim Zwiers (1922–2019), from whom she also commissioned multiple bookplate designs. In a single exchange, Pace sent Zwiers an astounding eighty-nine bookplates from her catalogue of personal ex-libris. Zwiers offered his critique of her selections, and not surprisingly, he also requested that she scale back any subsequent exchanges. The number and variety of Pace's personal designs indicate the catholicity of her collecting habits. Although most of her bookplate designs were commissioned artworks, she did have some examples of commercially available printed labels, such as her "From the Pantry of" bookplate (Figure 23).

FIGURE 23. *From the Pantry of: Irene D. Pace,* photomechanical print, 1956. (Andrews Memorial Bookplate Collection of Irene D. Andrews Pace, Robert B. Haas Family Arts Library, Yale University)

For Pace and many other collectors, the bookplate functioned not only as a mark of ownership but also as a form of currency. Akin to the economics of any other art market, bookplate collectors assign values to different artists, patrons, styles, etc. And ever the conscientious collector, Pace wanted to reciprocate exchanges with items of equal value. She strove to have something in-kind to exchange with all bookplate collectors – novices and connoisseurs alike. Pace once remarked: "If a young collector sends me a printed label, I can't afford to send back an expensive etching. But I don't like to return the label. Everyone has to begin, and I know how I felt if anyone returned my exchanges. So I have had nearly three hundred different style bookplates made for myself, and I send back to any exchanger what is a fair return."[66]

[48]

Pace kept a meticulous accounting system for these exchanges and recorded the dates and details on index cards. For example, she began a bookplate exchange with Dr. Hans Laut of Frankfurt, Germany, in April of 1954. Pace sent three of her own bookplates to start, which were nos. 124, 5, and 146 according to the chronologically sequential catalogue numbers that Pace assigned to her personal designs. These were designs by Ernest Huber (1910–2006), William McAllister Turner (1901–1976), and Lynd Ward (1905–1985), respectively. Pace received two bookplates from Laut in reply, plus a return of her no. 5 bookplate by Turner. After several volleys, Pace discontinued their exchanges in February of 1955, as she was vexed by the number of returned bookplates. She writes that "[Dr. Laut] said they were poor work & he didn't like them! So I didn't answer."[67] Laut did contact Pace again in 1959, and another five bookplates were sent and received, with their correspondence continuing into 1961. This fair-trade ethos was, however, only part of the rationale behind Pace's nearly 300 personal ex-libris designs.

Owners of Books

In 1936, little more than a decade into her bookplate collecting, Pace published *Owners of Books: The Dissipations of a Collector*. The subtitle implies an air of frivolity or amusement, but of course there is conviction in her bookplate-collecting pursuits. Yet in her introduction, Pace asserts "this is NOT a book about bookplates, but rather concerns itself with those who owned or made them."[68] She continues:

> There are odds and ends of gossip that lead one thru curious by-ways of history, literature and art, and the bookplate has been to me, the arrow which pointed the way to a closer contact with the lives and times of owners of books....
>
> [I]f the spirit of one's investigations be not malicious, the study of bygone individuals, in even the most personal manner, will yield much in the way of minutiae and curiosa which often throw more light into the hazy past than the better known and often epoch making acts of these same giants.[69]

Such an approach was manifest in Pace's collecting practices. As Mr. Pace later recounted: "When she found facts of interest about the owners, she was not content simply to make a reference to the work, but copied out the significant information on the loose-leaf sheets upon which the bookplates were mounted. This was tedious and laborious, but she felt that enough information should be with the plate to reveal the basic nature of the owner."[70] Such detailed documentation was critical to recreating these moments of connection. Of course, the more minute and curious the details (i.e., the more personal), the closer the connection.

Pace had only commissioned sixteen personal ex-libris before the

publication of *Owners of Books* in 1936, and that total also includes a few bookplates designed for immediate family members. But her approach to bookplate collecting still provides insight into her accumulation and dissemination of so many personal ex-libris in the years following. Be they bygone individuals or just artists and collectors at a distance, Pace sought meaningful connections through her bookplates.

Self-Fashioning

By commissioning her own bookplates, Pace gave form to her interests and tastes. She also memorialized key life events such as birthdays, holidays, anniversaries, etc. According to her husband,

> she liked to commemorate her travels with bookplates giving some of the atmosphere of the places visited, and she never tired of plates relating to her other hobbies. These hobbies were reflected also in books she collected, and it was natural that a bookplate with a flower, embroidery, shell, or cookery theme should be used in a book on the pertinent subject.[71]

Besides her travels, hobbies, and book collecting interests, some of Pace's designs even represent the bookplate enterprise itself. For example, the embowed arm of an armorial bookplate design from Bissiri Brothers reappears in Pace's "Ex Bibliothéca" design from Robert Cave-Browne-Cave. These are catalogue nos. 35 and 40, dating from 1947 and 1948, respectively (Figures 24 and 25). Pace's eclectic approach signals a shift in the purpose of the bookplate from simple identification and into the realm of identity. For Pace, the bookplates served as a site for self-fashioning.

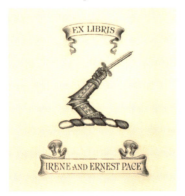
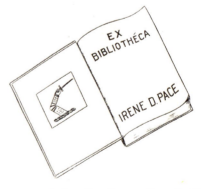

FIGURE 24. Bissiri Brothers, *Ex Libris Irene and Ernest Pace,* photomechanical print, 1947. (Andrews Memorial Bookplate Collection of Irene D. Andrews Pace, Robert B. Haas Family Arts Library, Yale University)

FIGURE 25. Robert Cave-Browne-Cave, *Ex Bibliothéca Irene D. Pace,* 1948, photomechanical print, 1948. (Andrews Memorial Bookplate Collection of Irene D. Andrews Pace, Robert B. Haas Family Arts Library, Yale University)

Pace's first commissioned bookplate, for example, was a birthday gift from her first husband, Dr. Edmund Andrews, which she received in 1924 (Figure 26). Beyond its commemorative significance marking a birthday, this example also demonstrates "the influence that bookplates of others had on her choice of plates for her own books."[72] In Pace's accompanying annotation, she recounts that her husband had asked the artist Ralph Fletcher Seymour (1876–1966) to emulate the bookplate of John Quinn (1870–1924), lawyer and famous bibliophile, which was designed by the artist Jack Butler Yeats (1871–1957). She records the scene depicted in the woodcut as "Cormac's Castle on the Rock of Cashel in Ireland" and indicates the plate was intended for her books on Ireland.[73]

Social Networks

With this very first commission, Pace created a social network of sorts with at least five nodes – herself, her first husband, the commissioned artist, the original artist, and the original patron – and not yet counting any exchange recipients. To reinforce these commission connections going forward, Pace maintained a keen interest in documenting the artist's process. She would file all her correspondence with the artist, which sometimes included her handwritten drafts of responses. And in the same voracious and thorough manner that she researched the rest of her bookplate collection, Pace filed newspaper clippings and any available process materials that she could obtain, including trial proofs, artist's proofs, and final prints; original sketches of both preliminary and final designs; often carved woodblocks or engraved plates; and sometimes other printed ephemera designed by the artists, such as greeting cards, exhibition announcements, etc. (often collectively referred to as "occasional graphics" by bookplate collectors). All these materials were filed together with the finished bookplate or bookplates, as Pace sometimes requested multiple versions or variants of a particular design. Such obsessive documentation of the artists' oddments served, in a way, as another form of self-expression, like the bookplate designs themselves. But these commissions also allowed her to cultivate social ties and connect with the artists on a personal level,

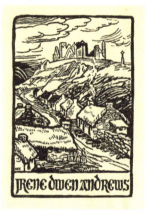

FIGURE 26. Ralph Fletcher Seymour, *Irene Dwen Andrews*, woodcut, 1924. (Andrews Memorial Bookplate Collection of Irene D. Andrews Pace, Robert B. Haas Family Arts Library, Yale University)

[51]

rather than just a transactional one. See, for example, the following case of mistaken identity.

Mistaken Identity

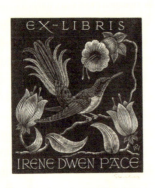

FIGURE 27. Ernest Huber, *Ex-Libris Irene Dwen Pace*, wood engraving, 1954. (Andrews Memorial Bookplate Collection of Irene D. Andrews Pace, Robert B. Haas Family Arts Library, Yale University)

Pace commissioned a handsome wood-engraved bookplate from the artist Ernest Huber (1910–2006). It is no. 138 on her checklist and dates from 1954 (Figure 27). Huber's design features a bird perched on a delicate vine and surrounded by a triangular composition of three flowers. This is one of many examples representing Pace's interests in ornithology and horticulture. Correspondence preserved in the archive, including one of Pace's handwritten draft responses, uncovers a curious interaction with Huber.

In her letter, Pace describes having read a *Los Angeles Times* article about an artist named *Ernst* Huber (1895–1960), who had recently visited Los Angeles.[74] Pace was surprised that Mr. Huber had traveled all that way and not bothered to telephone – either to pay a social call or make dinner plans. A few days later, she received a response from *Ernest* Huber, located in France, and she seized this funny moment of confusion as a chance to engage the artist in further dialogue. Huber writes back promptly: "To answer your curiosity I will send my letter by air-mail," and he goes on to explain the two artists' surname is a common one, and though there is no relation, he does remark some uncanny similarities – their wives share the same first initial, and he, too, often paints watercolor sketches. For him, sadly, Los Angeles is too far to travel, "but if ever it would be so, as we must swear to nothing, in our short life, you will be assured that we will not forget to phone you." And he reciprocates by sending his own self-image, in the form of a photograph, to "clear the mystery for you and leave you doubtless."[75]

Minutiae and Curiosa

Some may dismiss Pace's collecting pursuits as nothing more than bibliophilic eccentricity or discount her many personal ex-libris as solely a means of acquiring more bookplates. Indeed, there is a consumptive aspect to her numerous commissions. Perhaps she could have achieved comparable results, while still adhering to her fair-trade principles, with fewer bookplate

designs. But Pace's bookplate endeavor was so much more than a numbers game. Every aspect of Pace's personal ex-libris – the exchanges with other collectors, the commissions with artists, the obsessive recordkeeping – had a social dimension, fostering a sense of closeness, even belonging. In fact, Pace eschewed invitations to luncheons, matinees, and the like because such daytime engagements would have taken precious time away from her bookplate collecting.[76] And in the end, making mark after mark of book ownership provided Pace with a platform for self-fashioning and social connection, including connection with herself.

Pace engaged her personal ex-libris in the same manner she describes in *Owners of Books*. As artifacts, her bookplates were both informational and artistic, indexical as well as symbolic. And for Pace, their power was in their transportive potentiality. She could relive her life's milestones and relish her varied interests. Similar to the phenomenon she describes in *Owners of Books*, the documentation of her ex-libris "yield[ed] much in the way of minutiae and curiosa which often thr[ew] more light into [her own] hazy past."[77]

As marks of book ownership, bookplates are imbued with the properties of possession and control. Therefore, the accumulation and dissemination of so many personal ex-libris could be read as a concerted effort to secure a kind of ownership of the self. For Pace, both the image-making and the circulation of self-images were creative acts – a kind of performance of the private self for public viewing. But Pace's multitude of bookplates is ultimately a testament to the constructedness and elusiveness of selfhood.

These conditions of constructedness and elusiveness are important to remember, since the combination of Pace's bookplates and recordkeeping has a diaristic quality that can almost be read as her memoirs. But as a product of human agency, her archive (like all archives) is inherently incomplete and fallible.[78] Nevertheless, as a researcher, I feel an affinity with Pace. Her on-again, off-again bookplate exchanges and the short-lived case of mistaken identity are examples of exactly the kinds of momentary, personal connections that compelled Pace as a bookplate collector. And they are the minutiae and curiosa by which future researchers will find closer contact with Pace for years to come.

Addendum Macabrum

In closing, let us return to the bookplate within the book, and to Pace's own copy of *Owners of Books* (1936), which is also now held by the Yale Bookplate Collection. Pasted inside is bookplate no. 15 from Pace's catalogue, her *Ex Bibliotheca Macabrum* designed by Michel Fingesten (1884–1943) (Figure 28). Pace commissioned this bookplate in 1934 for yet another of her collecting interests – books on the "Dance of Death." Memento

mori were a specialty of sorts for Fingesten, whose graphic work traversed political, fantastical, and erotic motifs, – all of which can be seen in the remarques of this bookplate. Beyond the macabre subject matter, the etching is heavily textured, which gives the card-playing scene a murky quality that intensifies its otherworldliness. At the conclusion of *Owners of Books*, Pace resigns herself to "treasur[ing her] bookplates as isolated marks of ownership" and concedes that "the books in which they chance to lie can stand upon their own feet."[79] But the appearance of this bookplate, *Ex Bibliotheca Macabrum*, within this title, *Owners of Books*, has an incredible hall-of-mirrors-like effect. As a meditation on the fragility of life and ultimate surrender of worldly possessions, it effects a critique of both the book- and bookplate-collecting enterprises.

Ernest Huber's reply to the earlier mistaken identity episode, insisting that "we must swear to nothing, in our short life," is also a reminder that the memento mori is always close at hand with bookplates.[80] Candles, hourglasses, skulls, and many other visual codes for vanitas, or symbols of mortality and worldliness, have long been popular subject matter for ex-libris (and other art forms).[81] Pace herself commissioned several ex-libris designs featuring memento mori. And her approach to bookplate collecting, when considered from a somewhat more morbid angle, provided her with a material context by which to connect with book owners from the past and then discover some personal detail in order to bring them back to life.

FIGURE 28. Michel Fingesten, *Ex Bibliotheca Macabrum Irene D. Andrews,* etching, 1939. (Andrews Memorial Bookplate Collection of Irene D. Andrews Pace, Robert B. Haas Family Arts Library, Yale University)

Of course, a bringing back to life presupposes a death. And the bookplate is not unlike a tombstone. It provides biographical details and commemorates an individual's interests in books, bookplates, or both. But rather than having one final resting place (e.g., a plot in a cemetery), an ex-libris allows one to be "buried" in hundreds or thousands of books and bookplate collections. Undoubtedly there is a kind of longing for legacy with Pace's bookplate collecting and commissioning, and as Lowenhaupt has promised: "As long as our Library lasts her wonderful collection will remain intact and she will have in it an immortality that she herself created."[82]

[54]

BOOKPLATES OF PAST GROLIER CLUB MEMBERS

∴

NOTE: *An asterisk (*) indicates member at time of death.*

THE GROLIER CLUB
Proof of bookplate by Edwin Davis French (MEMBER 1899–1906*),
designer and engraver, 1894

Edwin Davis French was perhaps the greatest American bookplate artist of the Gilded Age. He designed and crafted plates for some of the most important bibliophiles – and bibliophilic institutions – of the turn of the twentieth century, including many early Grolier Club members, the Library of the Metropolitan Museum of Art, and the New York Public Library. A native of New England, French studied at Brown University and later accepted a position at the engraving firm of W. D. Whiting, where he remained until 1894. French then went on to earn his livelihood through making bookplates. His characteristically intricate, detailed, extravagant designs soon became collectibles in their own right. The Grolier Club's plate ranks among French's most grandiose works. It depicts the Club's patron, Jean Grolier, paying a visit to the publishing house of Aldus in Venice. Other vignettes display various aspects of the printing arts. The plate is a testament to French's incredible skill and the high standing of the ex-libris art form in the late nineteenth century. Throughout its history, the Grolier Club has had a series of bookplates, some made for specific collections, others for general library use. The designers include, besides French, Howard Pyle, George Wharton Edwards, Joseph Blumenthal, and Jerry Kelly, and are recorded in Eric Holzenberg's definitive account, *Three Gold Bezants, Three Silver Stars: The Arms of the Grolier Club, 1884–1984*, published by the Club in 1999.

ELMER ADLER
(MEMBER 1928–1962*)
Rockwell Kent, designer; Pynson Printers, printer, 1927

The works of the legendary illustrator and printmaker Rockwell Kent possess a distinctive, modernist aesthetic, and many mid-twentieth-century American collectors commissioned him to design their bookplates. A native of Rochester, New York, Adler attended Phillips Exeter and took courses at the University of Rochester and Harvard before returning home to revitalize the advertising side of his family's men's clothing manufacturing company. He soon came to New York ("to lose his fortune," said fellow Grolier member Frederick Adams) to establish Pynson Printers in 1922, then helped start and finance *The Colophon: A Book Collector's Quarterly*, and became a major force in the publishing and book worlds in the mid-twentieth century as designer, typographer, patron, and facilitator par excellence. The long, productive association between Adler and Kent began when the artist provided the striking illustrations for the Pynson Press edition of Voltaire's *Candide*, the first book published by Random House. Adler moved to Princeton with his collections of rare books and prints to found the library's department of graphic arts and endowed the university's book collecting prize. Late in life Adler created the Casa del Libro, in San Juan, Puerto Rico.

· ·

FRANK (MEMBER 1914–1981*) & HELEN ALTSCHUL
Joseph Winfred Spenceley, designer and engraver, 1913

A senior partner at the investment firm Lazard Frères, Altschul had come under the influence of the charismatic Yale professor of English Chauncey Brewster Tinker, a distinguished collector himself who served also as the university's curator of rare books (and of course a Grolier Club member). Altschul inaugurated the Yale Library Associates in 1924 and presented his alma mater with a fine George Meredith collection and other gifts. He was also a letterpress printer, operating the Overbrook Press for many decades with his wife, Helen Lehman Goodhart Altschul, who was also a trustee of Barnard College. The Altschuls supported many liberal causes, with Frank proudly gaining a place on Richard Nixon's "enemies list." Joseph Winfred Spenceley, one of the leading American bookplate artists of the early twentieth century, designed their bookplate.

JOSEPH MANUEL ANDREINI
(member 1907–1932*)
Lucien Pissarro, designer; Lucien and Esther Pissarro, Eragny Press, engravers and printers, ca. 1907

This remarkable piece, presenting a mounted ex-libris in a specially made folded paper enclosure inscribed to the Grolier Club, testifies to the high standing bookplates once held as an art form. Created by Lucien Pissarro, the French-born, London-based son of Impressionist painter Camille Pissarro, the bookplate itself was printed by Lucien and his wife Esther's private Eragny Press. Joseph Manuel Andreini, a leading collector of fine printing who was also an enthusiast for bookplates and stamps, was a member of the Wall Street banking firm Lawrence Turnure & Company. One of only twenty-five copies, the leaflet even features a charming remarque on the lower right edge of the plate.

. .

WILLIAM LORING ANDREWS (member 1884–1920*)
WILLIAM KEENEY BIXBY (member 1904–1931*)
Edwin Davis French (member 1899–1906), designer and engraver, 1894 (Andrews), 1906 (Bixby)*

These bookplates belonged to major collectors of the time who had the good fortune to retire early and devote themselves to philanthropy and bibliophily. One of the nine founders of the Grolier Club, William Loring Andrews was forty-two when he left the family's successful leather business. His library of English and American literature (also early printed books, illuminated manuscripts, prints, and maps) was justly celebrated, and he took active roles as donor and officer at both the Grolier and the Metropolitan Museum of Art. Andrews also wrote, and largely self-published, a notable series of "books about books" issued in limited editions and sometimes elaborately bound by the Club Bindery, which he helped to inaugurate. (*Gossip about Book Collecting*, 1900, was a typical title.) William K. Bixby, in true Horatio Alger fashion, rose from teenage baggage handler on a small railroad to owner of the American Car and Foundry Company, able to retire at age forty-eight. Rich enough to compete with the likes of J. P. Morgan and Henry Huntington, Bixby spent the rest of his life supporting institutions in his adopted city, St. Louis, and assiduously acquiring rare books, literary and historical manuscripts, and fine art. Much of his collection went to the St. Louis Art Museum and Washington University. Bixby's omnivorous passion for collecting is represented in his bookplate by an octopus.

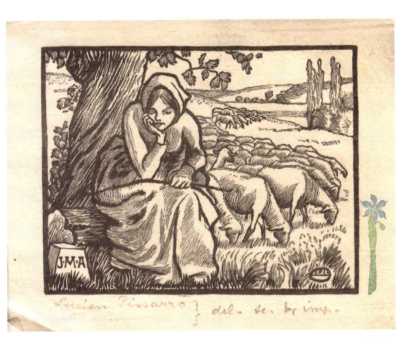
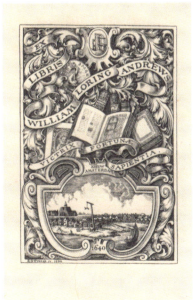
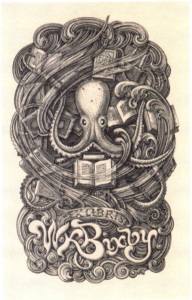

WALTER BAREISS
(MEMBER 1974–2001)
Georg Baselitz, designer, 1974

Molly Bareiss commissioned this bookplate, by Neo-expressionist/postmodern artist Georg Baselitz, for her husband in 1974, the same year he was elected to the Grolier Club. A true cosmopolitan (born in Germany, emigrated to the United States in 1937, graduated from Yale, and eventually spent half of each year in Europe), Bareiss ran an international textile business. He formed one of the world's best private collections of African art, along with collections of Asian, classical, and twentieth-century art, and had relationships with a number of institutions, including the Museum of Modern Art, the Getty Museum, and the Yale University Art Gallery. For our purposes, it is the nearly 1,800 modern artist's books he and his wife donated to the Toledo Museum of Art that merit attention. Bareiss referred to the figure on his bookplate as an "angel or the winged victory," adding, "The artist even decided to sign every single one of the 4,000 bookplates which he produced for me."

· ·

CLIFTON WALLER BARRETT
(MEMBER 1940–1991*)
Clifton Waller Barrett, designer, probably 1950s

Clifton Waller Barrett worked as an executive at the Munson Steamship Line in New York and, after moving to the city, developed an almost all-consuming interest in American literature. He donated his astounding collection, which aimed at completeness in canonical and forgotten works from colonial times to Stein and Hemingway and included key manuscripts (such as *Leaves of Grass*) along with thousands of letters, to the University of Virginia in 1960. He wrote of his ex-libris: "This bookplate is of my own design but is based on the bookplates of my ancestors . . . of which I have two examples."

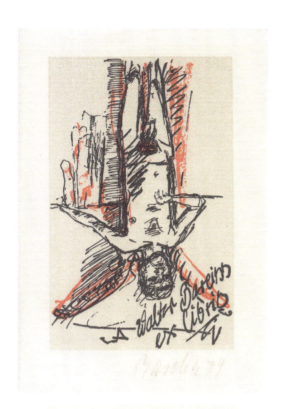

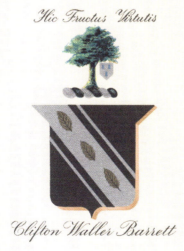

ALFRED JEROME BROWN
(MEMBER 1910–1923)
Alfred Jerome Brown, designer and engraver, 1906

An extraordinarily accomplished amateur designer of bookplates whose intricate copper engravings rivaled the work of Edwin Davis French and Sidney Lawton Smith, Alfred Jerome Brown was a medical doctor by profession. Educated at Yale and at the College of Physicians and Surgeons at Columbia University, he moved to Omaha following World War I, joining the faculty of the University of Nebraska Medical School. (Brown naturally designed the medical school's bookplate.) The plate depicts many symbols of Brown's profession and other interests, including a skull, microscope, and medical texts, as well as a pipe, gun, and outdoors scene. He presented this signed proof to the Grolier Club in 1906.

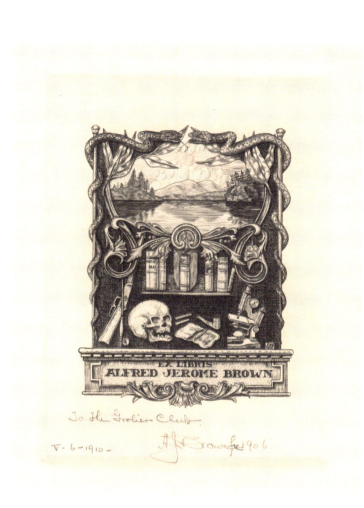

BEVERLY CHEW
(MEMBER 1884–1924*)
Sketches and proofs for a bookplate by Edwin Davis French
(MEMBER 1899–1906), *1895*

The design and fabrication of a bookplate could be a long and complicated process involving the tastes of the patron and the skills of the artist, engraver, and printer. The process can be seen in Edwin Davis French's painstaking work in making a bookplate for Beverly Chew, a prominent founding member of the Grolier Club who served as its librarian from 1887 to 1892 and as president from 1892 to 1896. Chew was associated with the Metropolitan Trust Company of New York and had the means to gather one of the most "golden" collections of the "golden age" of book collecting. The multi-section Anderson Galleries auction of his extensive library was a sensation, bringing to the market a rich assortment of books of hours, incunabula, illustrated books, and English literature – and the news that the early English poetry (2,000 volumes alone) had been purchased as a unit by Henry E. Huntington. The introduction to the sale catalogue aptly summed up Chew's bibliophilia: "Mr. Chew's books were his dearest possessions, the chief joy and interest of his later years, and he knew each book personally, as a man knows his dearest child."

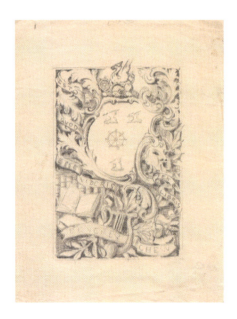

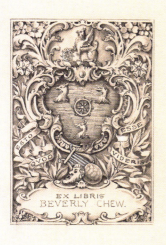
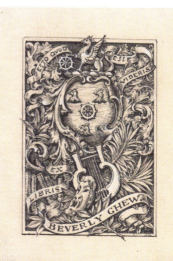
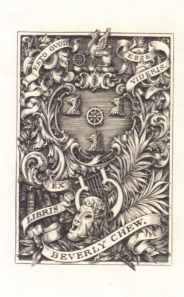

WILLIAM L. CLEMENTS
(MEMBER 1920–1934*)
Tiffany & Co., designer and printer, ca. 1910

"Tiffany" has long been synonymous with New York–style luxury and elegance. The stationery department of Tiffany & Company brought this reputation to the production of bookplates, largely in what might be termed an "aristocratic" style with an armorial above a name in script lettering. William L. Clements made his fortune supplying the steam shovels and cranes used in the building of the Panama Canal. Soon after the turn of the century he began to collect Americana, focusing on two areas of history – "the discovery, exploration, and colonization of America by Europeans from the 15th through the 17th centuries, and late 18th century colonial and revolutionary America." Clements had graduated from University of Michigan in 1882; becoming chairman of the university's board of trustees, in due course he gave the school money to endow and build a separate library to accommodate his growing collection. When the elegant William L. Clements Library opened in 1923, it was immediately recognized as a major repository of Americana, holding 20,000 rare books and a mass of archives and manuscripts. Clements also commissioned leather bookplates from Tiffany & Company.

. .

AUGUSTIN DALY
(MEMBER 1889–1894)
Maker unknown, 1899

Born in North Carolina in 1838, John Augustin Daly became one of the most important figures in American theater in the nineteenth century, variously a drama critic, director, theater manager, and playwright. Naturally, he gathered an extensive library devoted largely to the theater. The *Journal of the Ex-libris Society* in 1902 offered an amusing secondhand story of his bookplate, drawn from an article by David Russell Jack in the periodical *Acadiensis:* "After the death of this great collector, and when his library was to be disposed of, it was discovered that he had never been the possessor of an Ex-libris. Fully aware of the great desire which many people have for owning a book which bears the label of a great man, the persons in charge of the sale hurriedly ordered a book-plate bearing an enormous monogram formed of the letters DALY, a copy of which was pasted in the front of each volume before it was offered for sale."

Clements

THEODORE LOW DE VINNE
(MEMBER 1884–1914*)
George Fletcher Babb (MEMBER 1884–1897), *designer; Edwin Davis French*
(MEMBER 1899–1906*), *engraver, 1895*

Theodore Low De Vinne's life story is closely intertwined with the history of the Grolier Club. Perhaps the most important "artistic" commercial printer of his era in New York, if not the United States, he helped found the Club in 1884 and produced most of the organization's publications and ephemeral pieces for the next two decades. Universally recognized as the "dean" of American printers, De Vinne was a tireless promoter of the book arts and wrote important works on the history of printing and typography, including *The Invention of Printing* (1876), *Historic Printing Types* (1886), and *A Treatise on Title-Pages* (1902). Oddly enough, he did not design his own bookplate, entrusting the task to George Fletcher Babb, the architect responsible for the De Vinne Press's building in Lower Manhattan. The plate was engraved by Edwin Davis French, but the printer has not been identified.

. .

ROBERT ELWELL
(MEMBER 1968–1977)
Reynolds Stone, designer; Clarke & Way, printer, 1964

Reynolds Stone was a renowned English engraver, typographer, and painter. Collector Robert Elwell shared his memories of working with Stone to design his plate. "For such an ephemeral little piece, it carries a weighty history," he observed. "I first wrote to Reynolds Stone in 1964, asking if he would care to do [a bookplate] for me. He wrote back saying that he would, and did I have any particular sort of plate in mind? Since I have always collected a motley assortment of books, I replied that if there were to be any motif for the plate, other than a calligraphic treatment of my name, it ought to be a magpie. The idea amused him and a lengthy – and delightful – correspondence ensued, out of which the enclosed plate was produced. More importantly, a friendship was produced." (Elwell's "motley assortment of books" was in fact distinguished by much modern fine printing and illustrated books, German and French.)

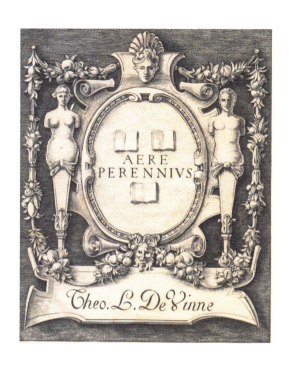

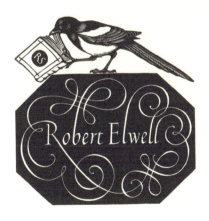

DANIEL B. FEARING
(MEMBER 1887–1918*)
Sidney Lawton Smith, designer and etcher, 1899

Appropriate for a one-time mayor of a seaside city with a fishing fleet, the literature of angling was the focus, or rather obsession, of Daniel B. Fearing of Newport, Rhode Island. The title of one of his earliest privately printed publications, *Check List of Books on Angling, Fish, Fisheries, Fish-Culture, Etc. in the Library of Daniel B. Fearing* (1901), hints at what his collection would ultimately contain. Eventually, the 11,500 books that were donated to Harvard in 1915 included a multitude of editions of Walton's *The Compleat Angler*, whaling voyage logbooks from New Bedford and Fair Haven, Massachusetts, and just about every work, ancient or modern, on the subject. Angling bookplates were more than a side interest; Fearing gave Harvard nearly 4,000 of these, and more are in the Grolier Club archive, with many recorded in a catalogue that accompanied a Grolier exhibition in 1918.

. .

HELMUT N. FRIEDLAENDER
(MEMBER 1975–2008*)
Maker unknown, ca. 2000

The diminutive size of Hal Friedlaender's bookplate belies the extent – and importance – of the rare book and manuscript collection assembled during the last four decades of his long life. Born in 1913 in Berlin, he fled the Nazi regime in 1933 and eventually made his way to the United States to pursue a career in investment banking. His collecting interests centered on medieval manuscripts and incunabula but extended to private press books and works in European and American culture that appealed to him. Much of his library was very successfully auctioned by Christie's in 2001 – with the collector sometimes repurchasing from dealers books he had sold! The tiny label is believed to have been the gift of a hopeful curator eager to entice Friedlaender to donate to his or her institution.

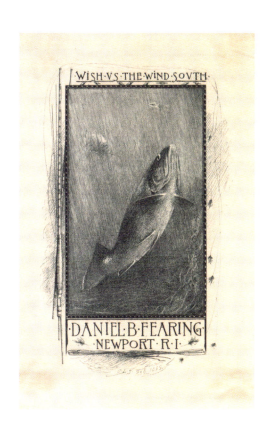

FREDERICK RICHMOND GOFF
(MEMBER 1941–1982*)
Maker unknown, probably 1930s

Renowned for his scholarship on early printed books, Frederick Richmond Goff spent his career at the Library of Congress, becoming Chief of the Rare Book Division in 1945. (Goff's magnum opus, *Incunabula in American Libraries: A Third Census of Fifteenth-Century Books Recorded in North American Collections*, published by the Bibliographical Society of America, 1964, remains a standard reference work.) When Goff contributed this ex-libris to the 1976 Grolier Club bookplate exhibition, he wrote: "Hardly distinguished, but my Mother had it made for me. I usually cut it down when I make use of it. The theme seems to be 'The Three Little Pigs' – or are they Boars? – certainly not bores." Amelia Seabury Goff likely had the bookplate printed in the mid-1930s when her son, then a student at Brown University, worked for Margaret Stillwell (member 1977–1984*), curator of the Annmary Brown Memorial Library.

. .

BERTRAM GROSVENOR GOODHUE
(MEMBER 1913–1924*)
Bertram Grosvenor Goodhue, designer, ca. 1900

An eminent architect well known for his work in the Gothic Revival and Spanish Colonial Revival styles, Goodhue was also a consummate designer of books, typefaces, and many personal and institutional bookplates, including his own. Goodhue's famous buildings include the Los Angeles Central Library, the Nebraska state capitol, St. Bartholomew's Church (just up the block from the Grolier at 60th Street and Park Avenue) – and the Grolier Club itself. Highlights of his typographic oeuvre include the massive *Altar Book: Containing the Order for the Celebration of the Holy Eucharist According to the Use of the American Church*, printed by the Merrymount Press in 1896 with borders and ornaments in the Kelmscott manner, and the Cheltenham typeface (completed 1902), for many years one of the most commonly used display fonts. In 1931, the Club published *Book Decorations by Bertram Grosvenor Goodhue* in his honor.

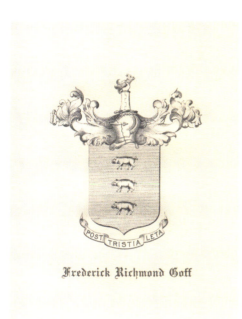

Frederick Richmond Goff

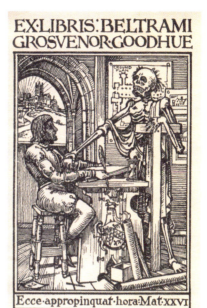

CHARLES ELIOT GOODSPEED
(MEMBER 1918–1950*)
Sidney Lawton Smith, designer and etcher, 1904

Charles E. Goodspeed was a Boston bookseller, bibliographer, and antiquary. His evocative autobiography, *Yankee Bookseller: Being the Reminiscences of Charles E. Goodspeed* (1937), tells the story of Goodspeed's Bookshop (later run by his son, George, also a Grolier member), which opened in 1898 on Park Street, across from Boston Common, and operated from that location for thirty-two years, before moving to Beacon Street. Goodspeed's specialized in Americana, but the owner's personal collecting extended into other areas, including the Victorian writer and artist John Ruskin (donated to Wellesley College). Franklin D. Roosevelt and Harry Houdini were among the shop's celebrity customers. The etched bookplate reproduces Paul Revere's famous engraving of the Boston Massacre of March 5, 1770.

. .

JACK W. C. HAGSTROM
(MEMBER 1969–2019*)
Paul Wightman Williams, designer; Harry Duncan, Cummington Press, printer, 1955 (printed 1971)

A noted pathologist (retired in 1981 as Professor of Pathology from Columbia Presbyterian Medical Center/Harlem Hospital Center), Hagstrom was a prolific writer on medical subjects and the author of descriptive bibliographies of the poets James Merrill, Thom Gunn, and Dana Gioia. His principal author collection was, however, of Robert Frost, whom he met while an undergraduate at Amherst College and to whom he became a close friend. Rich in manuscripts and correspondence as well as books and ancillary printed materials, this was given to Amherst, where Hagstrom, a considerable donor, also founded the college's library friends group. Hagstrom was proud of his Scandinavian heritage, and the "HK" initials refer to his full double-barreled last name, Hagstrom-Kilny. Paul Wightman Williams was long associated with Harry Duncan's Cummington Press, serving as its principal illustrator and printing associate. The bookplate was produced originally in 1955, then reprinted by the Spiral Press in 1963 and by the Cummington Press again in 1971 – each time, as Hagstrom wrote to the Grolier Club, with degradation of quality.

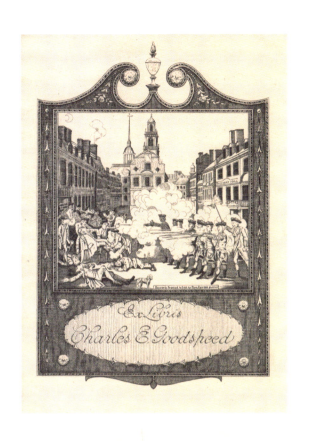

HAGSTROM

WILLIAM R. A. HAYS
(MEMBER 1926–1928)
Franz von Bayros, designer, 1911

Associated with the Decadent movement, Austrian Franz von Bayros earned lasting notoriety for his erotic illustrations. In 1911 he designed this suggestive plate for an Ohio lawyer who in his two-year membership left little trace at the Grolier Club. William R. A. Hays, however, had a big mania for bookplates, amassing more than 33,000 of them, largely through exchanges with other enthusiasts and book collectors. (His surviving correspondence on the subject runs to some 6,000 letters.) Hays seems to have been particularly keen on von Bayros's bookplates, for in 1913 he privately issued a book on the artist. "In looking over a collection of von Bayros Book-Plates," Hays writes, "one is most impressed by their beauty as a whole, and it is only by closer and longer study that one begins to realize the painstaking attention to detail, the true conception of spacing, and the elements of taste and style, all of which, bound together by an underlying and true sense of the artistic, go to make up this beauty."

. .

PHILIP HOFER
(MEMBER 1924–1984*)
(LION) *Eric Gill, designer, 1928;* (FLOWER) *Rudolph Koch, designer, ca. 1930*

Success in business before he turned thirty allowed Philip Hofer to pursue a life of bibliophily. His collecting focused on, indeed largely invented, a new field – that of illustration in all its forms, created in many periods and locales, ranging from illuminated manuscripts to illustrated books from the Renaissance and the following centuries to calligraphy and contemporary book arts. After positions at the New York Public Library and the Morgan, Hofer returned to his alma mater, Harvard, to found and become the first curator of – as well as the major donor to – the Department of Printing and Graphic Arts at the Houghton Library. Recognized by the *Book Collector* as one of "the greatest book collectors of our time" and a "conquistador . . . who conquered new realms of collecting," Hofer had an influence on the history of the book that cannot be overestimated. Unlike most collectors, he was not content to have just one bookplate, but commissioned several from internationally noted artists. Eric Gill, the English printmaker, sculptor, and type designer, produced the lion bookplate; the flower plate was the work of German master of lettering, typographer, and illustration Rudolph Koch (hand-cut in wood and hand-colored by his notable student, German-American Fritz Kredel, member 1970–1973).

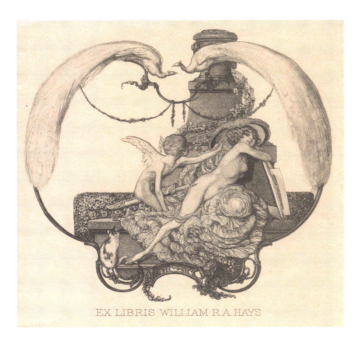

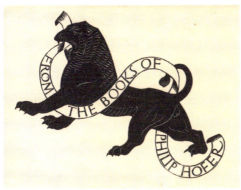

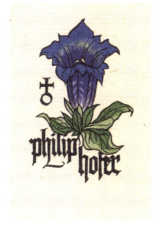

CHARLES ST. JOHN HORNBY
(MEMBER 1897–1911)
Maker unknown, ca. 1901

Son of a curate and a graduate of New College, Oxford, Charles Harold St. John Hornby was a partner in newsagents W. H. Smith & Sons and the founder and owner of the Ashendene Press, one of the great English private presses active from the late 1890s into the 1930s. Not unexpectedly for a producer of beautiful books, he gathered a sizeable (and notable) collection of early printing and illuminated manuscripts. While his other early bookplate has been attributed to Philip Webb, the architect, and a member of William Morris's decorating firm, this might well be the work of Hornby himself. The illustration derives from Jost Amman's woodcut of "Typographus. Der Buchdrucker [The Printer]," published in Hartmann Schopper, *Panoplia omnium illiberalium mechanicarum aut sedentariarum artium* (1568). A later book label, bearing only Hornby's name and address, was printed by the Ashendene Press.

. .

DONALD HYDE (MEMBER 1943–1966*)
& MARY HYDE, VISCOUNTESS ECCLES
(MEMBER 1976–2003*)
Reynolds Stone, designer, 1965

A New York attorney, Donald Hyde served as president of the Grolier Club from 1961 to 1965. He and his wife, Mary Morley Crapo Hyde, formed the best private collection in the world devoted to Samuel Johnson, James Boswell, and their circle. (Much of it derived from the *en bloc* purchase of the library of R. B. Adam and his son, both Grolier members.) Mary Hyde, who married David Eccles, 1st Viscount Eccles (another Grolier member 1984–1999), following her first husband's death, earned fame in her own right as a scholar and as one of the premier bibliophiles of our time. In addition to augmenting the eighteenth-century English material she had acquired with Donald Hyde (now at Harvard), Lady Eccles – incidentally one of the first women elected to the Grolier – gathered the most extensive private collection of Oscar Wilde books and manuscripts (bequeathed to the British Library). The oak leaves on the bookplate evoke the name of Four Oaks Farm, the estate in New Jersey that belonged to Eccles and her husbands.

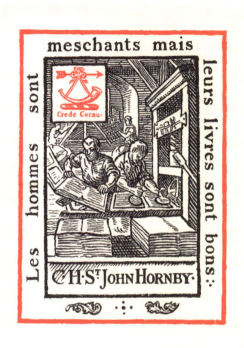

RICHARD LANDON
(MEMBER 1978–2011*)
Thoreau MacDonald, designer, ca. 1976

Richard Landon was the longtime head of the Thomas Fisher Rare Book Library at the University of Toronto. His large personal collection centered on "books about books," bibliography and the history of printing and publishing – subjects on which he contributed significant scholarship – but also included author collections, notably of the late Victorian Canadian-British science writer and novelist Grant Allen. Landon found the rural and nature-based emphasis of Thoreau MacDonald's art so appealing that he commissioned this bookplate around 1976. Landon's essay about MacDonald is included in the selection of Landon's writings, *A Long Way from the Armstrong Beer Parlour*, edited by Grolier member Marie Korey (elected 1982).

. .

ABE LERNER
(MEMBER 1974–2002*)
Leonard Baskin (MEMBER 1967–1976), *designer; Leonard J. Brodney, printer; Clarke & Way, typesetter, 1961*

Recognized as one of the country's finest typographers and book designers, and one with links to the likes of the great Bruce Rogers, among others, Abe Lerner had a long career as Director of Design and Production at World Publishing and Macmillan's New York branch. Lerner also worked as a freelance designer, sometimes in collaboration with his wife, antiquarian bookseller, boxmaker, and fellow Grolier member (1980–1988, 1998–2014*) Kit Currie. (The couple collected examples of modern fine printing together.) He served terms as chair of the Grolier's Committee on Modern Fine Printing and as a president of the Typophiles, which published his *Designing a Book* in 1993. Of his bookplate, Lerner said: "The thistles, in the field of grass, are emblematic of printers and book designers through the ages." The bookplate was designed by Lerner's good friend and fellow Grolier Club member, the distinguished artist, illustrator, and sculptor Leonard Baskin. A "compulsive book buyer" himself, Baskin created many ex-libris in both pictorial and typographic designs.

PAUL MELLON
(MEMBER 1957–1999*)
Macdonald and Co., designer and maker, probably 1930s–1950s

The name "Mellon" is synonymous with collecting, connoisseurship, and cultural philanthropy. Paul Mellon was the grandson of Thomas Mellon, founder of the Mellon Bank and patriarch of one of the United States' most prominent business families. A Maecenas of the twentieth century, Paul Mellon was famous for his love of thoroughbred racehorses, sporting art, British and French paintings, and rare books in several fields. Following in the footsteps of his father, Andrew Mellon, who had paid for the original building, Mellon provided funds to build the East Building of the National Gallery of Art in Washington, D.C., and donated significant paintings, particularly work by the Impressionists. Yale received Mellon's vast, unrivaled collections of British art and books, along with the Yale Center for British Art to house them. A further collection of Americana was bequeathed to the Virginia State Library. This leather bookplate features the name Oak Spring, the Mellons' Virginia estate, now a garden showplace open to the public and research center incorporating yet another collection, the library on horticulture, botany, and natural history formed by Mellon's wife, Rachel (known as "Bunny").

· ·

WALTER S. MERWIN
(MEMBER 1951–1980)
*William J. Watson (member 1954–1971), Easy Hill Press,
designer and printer, ca. 1950–1955*

A lawyer, collector, and occasional writer on bibliographical subjects, Walter Merwin served on the board of virtually every library in his native Buffalo, New York. In sending an example of his bookplate to the 1974 Grolier exhibition, he wrote that it "was designed by a good friend, and former non-resident member of the Grolier Club, Mr. William J. Watson, of Buffalo. Mr. Watson was a vice-president of the William J. Keller Printing Company. This was a commercial press which specialized in the printing of college yearbooks. Bill also operated – on a hand press in his basement at home – a private press he called the Easy Hill Press. The Easy Hill Press did some fine work during the '50s and '60s, printing in limited editions of, perhaps, a couple hundred copies, previously unprinted manuscripts for a club of Buffalo book collectors." The club referred to was the Salisbury Club, a local bibliophile society named for the first printer in Buffalo, founded by Merwin and Watson in collaboration with the rare book collection of the city's public library. It is worth pointing out that Watson and his wife, Marie (who joined with him in the several iterations of their personal letterpress operation), made a special visit to the Grolier Club on their honeymoon in 1941.

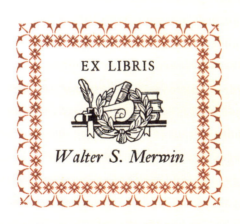

JOHN PIERPONT MORGAN
(member 1897–1913*)

*James Macdonald, designer and die-maker;
Macdonald and Co. or possibly the Club Bindery, maker, ca. late 1890s*

The most powerful financier of the early twentieth century, J. P. Morgan was the Gilded Age's consummate book collector. The great banker's staggering bibliophilic legacy lives on today at the Morgan Library & Museum on Madison Avenue at 36th Street in New York City. Morgan's collecting began in earnest in 1890; by the time he died in 1913, he had spent some $60 million ($1.6 billion in 2022 dollars) on rare books and art. He made a particular specialty of medieval illuminated manuscripts and incunabula, but took in literary and historical manuscripts, old master drawings, classical antiquities, Asian ceramics, and religious objects. Morgan's goal "was to establish in the United States a library worthy of the great European collections." Toward this end, he made spectacular acquisitions, among them a copy of the Gutenberg Bible and the manuscript of *A Christmas Carol.* James Macdonald, whose bookbinding firm bound many of Morgan's books, is credited with the design of this bookplate. It may have been made by the Club Bindery, an operation set up by Edwin Holden and other Grolier members in 1895 to produce bindings of exceptional quality. Macdonald made a similar plate for another major collector, Robert Hoe, a founder and first president of the Grolier Club. It was at the auction of Hoe's superlative library in 1911 (the most lucrative book sale yet held in America) that Morgan's librarian, Belle da Costa Greene, paid $42,000 for Caxton's edition of *Le Morte D'Arthur* (1486), at that time a record for a printed book.

THOMAS BIRD MOSHER
(MEMBER 1895–1923*)
Frank R. Rathbun, designer, 1897

Often – and perhaps a bit unfairly – castigated as the "pirate" of Portland, Maine, for publishing books without their author's permission, Thomas B. Mosher played an important role in both literature and book design in the late 1890s and first decade of the twentieth century. His firm focused largely on British writers, especially those associated with the Pre-Raphaelite and Aesthetic movements, such as William Morris, Dante Gabriel Rossetti, A. C. Swinburne, George Meredith, Oscar Wilde, and "Michael Field" – bringing them to the attention of American readers through a variety of inexpensive limited editions produced with a unique version of classical typography. Mosher gathered a considerable library, which served as a source for the texts he reprinted in his books and in his magazine, *The Bibelot*. This bookplate, derived from an Old German design, was the work of Frank R. Rathbun of Auburn, New York, a mechanical draftsman, illustrator, and writer of books on natural history. Early versions were printed on Japan vellum, but the scarcity of that material likely led Mosher later to turn to Van Gelder paper.

· ·

EDWARD NAUMBURG, JR.
(MEMBER 1947–1995*)
Joseph Blumenthal (MEMBER 1945–1990*), *Spiral Press, designer and printer, probably mid-1950s*

By profession a stockbroker, Naumburg came from a New York family prominent as patrons of music. He himself was an accomplished violinist whose bibliophile interests focused on American literature and the British novelists Joseph Conrad and (especially) Ford Madox Ford. Naumburg said of this bookplate, "Years ago, when I was actively collecting American children's books, Joe Blumenthal made this book label for me. It was exhibited with Joe's Spiral Press material at the Morgan Library in [January] 1966. The figure of the boy reading was taken from a woodcut (much reduced of course) of a New England juvenile ca 1820 – I don't remember the title." One of the prominent scholar-printers of the twentieth century, Blumenthal and his Spiral Press were responsible for many Grolier Club publications and much in the way of invitations and announcements. The Club co-published Blumenthal's memoir, *The Typographic Years: A Printer's Journey Through a Half-Century*, in 1982.

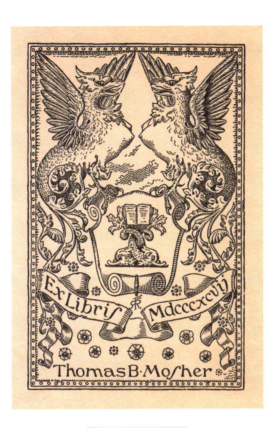

A. EDWARD NEWTON
(MEMBER 1890–1940*)

Charles Grosvenor Osgood, designer; Sidney Lawton Smith, etcher, 1909

"Eddie" Newton was unquestionably the best-known American book collector of the interwar period. Although he amassed a library of some 10,000 items, primarily English and American literature, it was the series of books on book collecting he wrote that made him famous. Beginning with *The Amenities of Book-Collecting and Kindred Affections* (1918), these approachable, highly entertaining works, filled with anecdotes, helped popularize the hobby among the general public. Indeed, some have credited Newton for creating the "boom" in book collecting, and the resulting increase in prices, which took place in the years before the crash of 1929. His bookplate, depicting Newton's favorite authors, Samuel Johnson and James Boswell, and devised as a *jeux d'esprit* at the suggestion of Princeton professor of English Charles Grosvenor Osgood, was created by the great Boston etcher/engraver Sidney Lawton Smith. Smith ranks second only to Edwin Davis French in terms of the sophistication and influence of his ex-libris art. The bookplate shows Johnson and Boswell engaged in conversation. Examples of the plate were pasted on the cover of the prospectus for first of the sale of Newton's books held at Parke-Bernet in 1941.

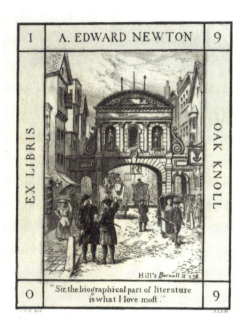

WALTER PFORZHEIMER (member 1930–1955*)
& WALTER L. PFORZHEIMER
(member 1935–2003*)
Silvain Guillot, engraver and printer, ca. 1925–1930

In what is surely a unique occurrence, no fewer than five members of the Pforzheimer family belonged to the Grolier Club – brothers Arthur, Carl, and Walter, Carl's son, Carl, Jr., and Walter's son, Walter Lionel Pforzheimer. With wealth derived from Wall Street, where he started as a $4 a week clerk, Carl (member 1918–1957) created a truly legendary library of English literature. One major portion, focused on Shelley and his circle, was donated to the New York Public Library by his son Carl, Jr. (member 1930–1996) and grandson Carl III in 1987. The University of Texas at Austin had purchased the early English poetry and drama, together with the Pforzheimer copy of the Gutenberg Bible, the year before; a George Gissing collection was later acquired by the Lilly Library, Indiana University. Arthur (member 1918–1949) left the financial world to become an antiquarian bookseller. Of the two Walters, the younger one was the best known. Considered a founder of the CIA, where he worked (after being in the OSS during World War II) from 1947 until his retirement in 1974, he served as the agency's first legislative counsel. He was also the curator of the CIA's Historical Intelligence Collection, at the same time forming the best private collection on the same subject – 5,000 books and other items (of which the most famous were Mata Hari's passport and volumes from Hitler's library) – bequeathed to his alma mater, Yale University. This bookplate, made for Walter senior by the Paris firm of heraldic engravers Silvain Guillot, was apparently used by his son when adding to an inherited collection of Molière and French bindings (also given to Yale). The image incorporates a view of the Petit Trianon at Versailles. Seymour de Ricci, the bibliographer and expert on provenance (honorary corresponding member 1909–1942) designed before 1930 a small name-label used by both Walter Pforzheimers.

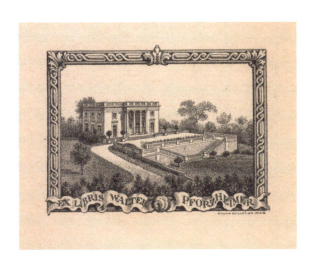

ROBERT R. RAYMO
(MEMBER 1979–2009*)
Jerry Kelly (ELECTED 1983), *designer and printer, 2011*

Grolier member Judith Raymo (elected 2007) commissioned this bookplate as a memorial to her husband, Bob, an internationally renowned scholar of medieval and Renaissance literature and professor of English at New York University. Assisted by Patricia Davalos, she inserted more than 1,000 bookplates into his collection of Chaucer's works, selections from which were exhibited at the Club in 2000. The "R" initial was designed by William Morris for the Kelmscott Press edition of *The Works of Geoffrey Chaucer* (1896).

. .

LOUIS J. RHEAD
(MEMBER 1887–1902)
Louis J. Rhead, designer, 1890

Born in England, Louis Rhead was an illustrator and author, today remembered as one of the foremost poster designers of the turn of the century. After training in London and Paris, he moved to the United States when he was twenty-four to take a job with D. Appleton, later working for R. H. Russell and other publishers. Prolific as well as talented, Rhead worked regularly for *Harper's* and *St. Nicolas*, among many periodicals, and illustrated literary classics, including *Robin Hood, The Swiss Family Robinson, Robinson Crusoe, Treasure Island, Kidnapped,* and *Heidi.* Befitting an artist who developed an obsession with fly fishing and with fishing flies (he published *American Trout-Stream Insects* in 1916), his own bookplate is a self-portrait "showing the owner wading and angling in the 'Beaver Kill,' about to net a trout."

FROM THE
CHAUCER
COLLECTION
OF
ROBERT R.
RAYMO

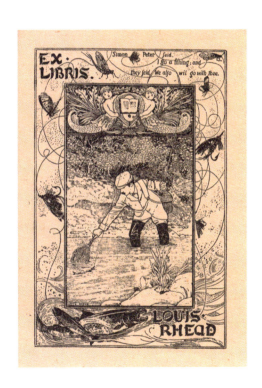

BRUCE ROGERS
(MEMBER 1928–1957*)
Arthur Allen Lewis, designer, 1927

One of the greatest American book and type designers of the twentieth century, Bruce Rogers established a reputation as a proponent of "allusive" typography and classical design. The creator of several well-known roman typefaces, of which Centaur is the most famous, Rogers was responsible for such celebrated books as T. E. Lawrence's translation of *The Odyssey* (1932), the Oxford Lectern Bible (1935), and *Fra Luca de Pacioli* (1933), considered by many to be the most beautiful of all Grolier Club publications. Somewhat surprisingly, although this master of type designed bookplates for individuals and libraries, he did not make his own. Instead, it was produced by Arthur Allen Lewis, a printmaker who taught at the Art Students League, possibly without Rogers's knowledge and intended for a Typophiles book. Rogers might have a hand in the design, however, since the plate proudly declares his Indiana origins.

. .

PHILIP & SYLVIA SPERLING
Philip Sperling, designer and printer, 1945

Immediately following the end of the Second World War, late in 1945, Staff Sergeant Philip Sperling had time in Germany before the Liberty ship *John W. Brown* brought him safely back to the United States. Given Sperling's love of books, he spent that time designing bookplates for himself and his young wife, Sylvia, using a deserted German printshop to print the plates. Examples of his bookplates can be found in his prized William Pickering collection. Philip Sperling was a longtime volunteer at the Grolier Club, and his daughter Amy Sperling continues the tradition.

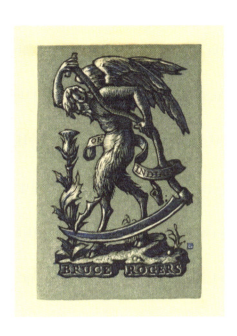

RODERICK TERRY

(MEMBER 1905–1933*)

Arthur Nelson Macdonald, designer and engraver, 1919

The Rev. Dr. Roderick Terry was born in Brooklyn, attended Yale, the Union Theological Seminary, and Princeton, and lived in Newport, Rhode Island. He was deeply involved with the Newport Historical Society and served as president of the Redwood Library from 1916 to 1933. With his brother, Seth Sprague Terry (who later joined the Grolier and remained a member until 1932), Roderick Terry amassed a considerable library of rare books, largely Americana, but encompassing high spots in literature and the history of printing. Note the presence of Jean Grolier's coat of arms on this etched plate by well-known engraver Arthur Nelson Macdonald.

. .

SIR EMERY WALKER

(HONORARY FOREIGN CORRESPONDING MEMBER 1920–1933*)

Kelmscott Press, printer, 1897–1898

A major figure in the "revival of printing" associated with the arts and crafts movement, Emery Walker was the foremost English typographical expert of his time. It was an illustrated lecture by Walker in 1888 that led his close friend and neighbor William Morris to found the Kelmscott Press. In pursuing his "typographical adventure," Morris relied on Walker's knowledge and used his company's resources in printing and photographic reproduction. This book label is one of a group printed by Kelmscott after Morris's death using the Golden Type he had designed with Walker's aid. Walker was later T. J. Cobden-Sanderson's partner in the Doves Press and advised many other printers and designers, including Charles St. John Hornby and Bruce Rogers, whose bookplates are also reproduced in this book.

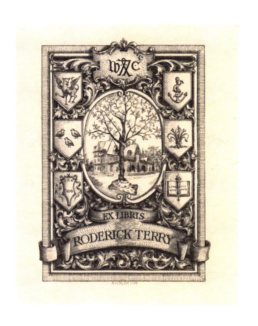

FROM THE LIBRARY
OF EMERY WALKER
NO. III THE TERRACE
HAMMERSMITH 🌸 🌸

MONROE WHEELER
(MEMBER 1936–1988*)

Schuyler Watts (MEMBER 1959–1973), designer and printer, early 1960s

More an impresario than a collector, Monroe Wheeler played a crucial role in promoting modern art and artists though am extended career at the Museum of Modern Art. His work at the Museum commenced in 1935 as a member of the Library Committee. In 1938, he was made Director of Membership; in 1939, Director of Publications; and in 1940, Director of Exhibitions. In 1944, he became a trustee. Wheeler had a serious interest in books, having cofounded the private press Harrison of Paris with heiress Barbara Harrison; he also served on the Grolier Club's Council. In giving the history of his bookplate, Wheeler explained that Schuyler Watts owned the type that once belonged to Wheeler's friend, the Dutch typographer Jan van Krimpen. The multitalented Watts was a collector of modern printing, an expert on Italian calligraphy, an occasional director and producer in New York theater, and the operator of a succession of private presses. His profession was that of a lighting designer, and he apparently resigned from the Grolier Club because of a dispute about a bill.

· ·

HARRY ELKINS WIDENER
(MEMBER 1909–1912*)

Walter Crane, designer; John Angel James Wilcox, engraver, 1908

By the time of his death aboard the *R. M. S. Titanic* in April 1912, Philadelphian Harry Widener had already established himself as a rising collector of English literature. With family wealth and an indulgent mother rich in her own right behind him, along with help from bookseller (and fellow Grolier member) A. S. W. Rosenbach, he had gone in for first editions, association copies, and manuscripts in a way that belied his youth. Widener built up excellent collections of favorite authors Charles Dickens and Robert Louis Stevenson. The charming image in this bookplate designed by the eminent British illustrator Walter Crane is both iconic and unintentionally ironic; a young woman holding a book looks out of a porthole onto the Atlantic Ocean, which would become Widener's grave only four years after it was made.

Ex
Libris

MONROE WHEELER

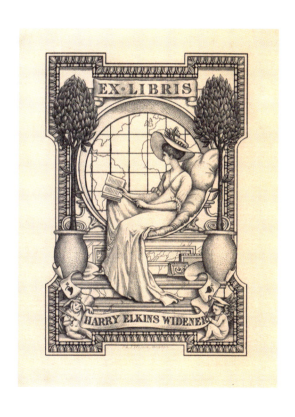

BOOKPLATES OF CURRENT GROLIER CLUB MEMBERS

ALEXANDER LAWRENCE AMES
(ELECTED 2016)
Olivetree Design, designer, 2022

Derived from historic prints in the rococo style discovered in the collection of the Winterthur Library in Delaware, Ames' bookplates evoke the opportunities and perils of intellectual voyage. This bookplate featuring a nautical scene uses an engraving by J. Miller found in J. Collins's ca. 1760s *A New Book of Shields: Composed of Variety of Ornaments & Trophies, Calculated for the Use of Artificers in General*. Lines from the poem "Qua Cursum Ventus" by Arthur Hugh Clough inspire an authentic exploration of one's scholarly and artistic interests. A dragon design used in a second bookplate is from Thomas Bowles's ca. 1740s *Compleat Book of Ornaments: Consisting of Variety of Compartments, Shields, Masks, Frize-work, Moresk-work &c.* and showcases a quotation from Christopher Marlowe's *The Tragical History of the Life and Death of Doctor Faustus*, intended to remind the viewer of the perils of unbridled ambition, even the realm of scholarship. For Ames, these bookplates commemorate a milestone in his bibliophilic and professional development. Research, volunteer, and internship experiences at the Winterthur Library helped him settle on a career devoted to special collections curation. Today, he serves as Associate Curator of the Rosenbach Museum & Library in Philadelphia, and cultivates scholarly and collecting interests focused on the history of early American religion.

. .

GEORGIA B. BARNHILL
(ELECTED 1979)
Darrell Hyder, designer and printer, ca. 2002

While she was serving as the Curator of Graphic Arts at the American Antiquarian Society, Barnhill and her husband donated to an acquisition fund for art books. Discovered by Nancy Burkett, the Librarian of the Society at the time, this bookplate's image – featuring a landscape artist's equipment – comes from a trade card from the A. Hoen & Co. lithography firm in Baltimore. The border of the image is printed offset, and the texts are printed letterpress.

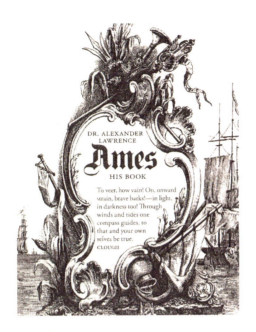

LISA UNGAR BASKIN
(ELECTED 2003)
Leonard Baskin (MEMBER 1967–1976), *designer, ca, 1985*

"Of the making of bookplates there is no end!" The drawing is of a Sibyl, and this is one of numerous proposed, and mostly rejected, designs for a bookplate for Baskin's women's collection by her husband, Leonard Baskin: "Leonard ultimately gathered all my 'rejects' . . . his original drawings, printed examples, typographic proofs, etc., and made a lovely little book of them for me. We had three book tickets for our joint collections. The women's collection had at least another three."

. .

SIMON BEATTIE
(ELECTED 2019)
Simon Brett, designer; Libanus Press, printer, 2005

"My bookplate was designed by the wood engraver Simon Brett in 2005, using two styles of engraving: a traditional English Bewick-like style for Exeter Cathedral (where I used to sing, and one of my collecting interests), and a more modern, European one (I was thinking of Post-War Soviet wood engravers; I studied German and Russian at university) for the reader and the books. The beech leaves are for Buckinghamshire, where I come from (and, indeed, still live)."

. .

ANDREW L. BERGER
(ELECTED 1995)
Proof etching for bookplate by Brigitte Simon, 1994–1998

A versatile French artist and close friend of Berger and his wife, Brigitte Simon (1926–2009) produced paintings, drawings, prints, and illustrated books, examples of which are represented in their collection. She created this single proof etching for a bookplate design as a gift following a visit to London with her artist husband, fellow artist Charles Marq, while the Bergers were living there (1994–1998). The bookplate has never been printed.

SUZE BIENAIMEE
(elected 2019)
Suze Bienaimee, designer and printer, 2018

"My bookplate honors the memory of my dear parakeet, Bella, as well as my bibliophile interests including contemporary artist monographs and contemporary poems (books, broadsides). I couldn't resist listing some of my other collecting interests: beauty, laughter, words, birds, numinous, noumenon and of course I have the collectors' love of the significant insignificant. Tarpino typeface is by contemporary artist, Raffi Tarpinian. (Note: Bella could count, identify primary colors and play basketball. Would reading, even book collecting have been next? (See YouTube.com, BellaEllaSparkles!)"

. .

JOHN R. BOCKSTOCE
(elected 1992)
Susan Kress Hamilton, Phineas Press, designer and printer, 1982

Bockstoce commissioned this engraving from Hamilton to adorn the books in the small library he carried aboard the *Belvedere*, his sixty-foot arctic expedition motor-sailer. On these travels, which occurred from 1982 to 2001, Bockstoce voyaged through the North Pacific, Bering, Chukchi, Beaufort Seas, the Northwest Passage, the North Atlantic, the Hebrides, Svalbard, the Faroe Islands, Iceland, Greenland, and Labrador.

. .

NANCY K. BOEHM
(elected 2012)
Nancy K. Boehm, designer, 2014

Searching for a new bookplate, Boehm was drawn to the words of artist Charles J. Chu: "I was awakened by one red leaf." She kept coming back to this image with its simple beauty and its message: "Isn't this how we become attached . . . to our books, to our collections, to our loved ones? Aren't we somehow awakened?" Taking advantage of digital technology, the bookplate is printed ink jet on Unryu paper (which literally means "Cloud Dragon Paper") with subtle cloud-like incisions made by the layering of long kozo (mulberry) fibers.

THOMAS G. BOSS
(ELECTED 1992)
John Kristensen, Firefly Press, designer and printer, 2012

Inspired by the decorations found on a Christmas menu printed by Kristensen at his Firefly Press, Boss contacted him to make this letterpress bookplate. The design achieves a luxurious feeling with small red and black ornaments and an unconventional rendering of Boss's name, which is broken up non-syllabically.

. .

WILSON BRAUN, JR.
(ELECTED 1992)
Will Carter, Rampant Lion Press, designer and printer, 1984

Braun long had admired Carter's labels and liked the connection with Reynolds Stone, whose work he had been acquiring as part of a collection focused on twentieth-century British wood engraving. Thus he commissioned this bookplate: "Stone was Carter's cousin and I chose the same 'Carter red' color that Stone had used for a Rampant Lion press device he had designed."

. .

LORD BROWNE OF MADINGLEY
(ELECTED 2010)
Gianni Basso Gosling, designer; Gianni Basso, printer, 2013

Lord Browne's bookplate is based on the coat of arms granted when he became a life peer in 2001. The elements reflect his professional life and his parents' background: The side supporters are Hungarian bears (referring to his mother), tethered with golden chains (representing business). The shield is decorated with ammonites (fossils often related to oil and gas). Above the shield is the baron's coronet, a knight's helmet, and a Norfolk bittern (referring to his father). The scale did not permit the inclusion of the motto "Momento historiae," roughly translated as "Do not lose the plot." The plates were printed by Gianni Basso in Venice – Browne's collection is primarily of illustrated books printed in (or simply about) Venice in the sixteenth to eighteenth centuries, up to the end of the Venetian Republic.

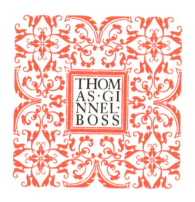

Wilson J C Braun Jr.

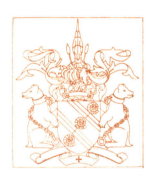

Bibliotheca Browniana

WILLIAM E. BUTLER
(ELECTED 1996)
Leo Wyatt, designer and engraver;
Will Carter, Rampant Lion Press, printer, 1979

Butler uses this calligraphic wood engraving on his finer books, as opposed to books related to his profession. In its design, medium, and style, this bookplate is meant to complement typographical elements of the books it adorns.

. .

REID BYERS
(ELECTED 2005)
Reid Byers, designer and printer, 2021

Byers describes his two bookplates as follows: For the general collection, "The quatrain is taken from my book rhyme, as published in the *New York Times* on December 26, 2021 and the woodcut is that of the playwright Terence made in Lyons in 1493. The graphic for the bookplate for the imaginary books collection comes from an old magic catalog. This design was the result of a long conversation with Chris Loker about the prospectus for my upcoming Grolier exhibition, 'Imaginary Books.' The intent was to express the idea that the imaginary exhibition, like a good stage magician, does not pretend the magic to be real, but does propose to entertain its audience by fooling them in spite of their being in on the jest." Byers edited both using GIMP 2.10.30 and printed them with an HP 4470 on Southworth Antique Laid paper.

. .

CHARLES CHADWYCK-HEALEY
(ELECTED 1999)
Richard Shirley Smith, designer; Libanus Press, printer, 1987

"I would like to submit my bookplate for inclusion in the forthcoming catalogue. It was created for me in the mid-1980s by Richard Shirley Smith, the well-known British artist, wood engraver, and muralist. The themes relate to my interests: birds, – an Arctic Skua, photography, a book and a manuscript as I was a publisher, a lily which is the family crest, and my great grandfather's yacht. Shirley Smith was a traditionalist and is most at home with classical themes and I remember he was uncomfortable about including a camera. By the time I met him his eyesight had deteriorated so much that he could not wood engrave any longer and he drew it out in pen on a much larger scale and it was then printed by offset by the Libanus Press in Marlborough, Wiltshire."

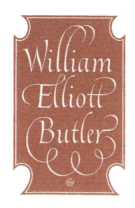

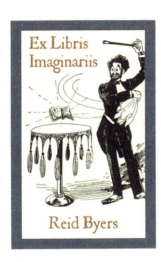

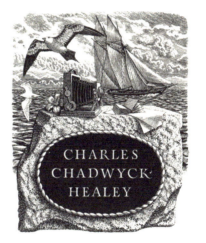

FERN COHEN
(ELECTED 2007)
Jerry Kelly (ELECTED 1983), *designer; Spectrum Graphics, printer, 2015*

As a botanical book collector, Cohen wanted her bookplate to combine flowers and books. While looking through her small collection of women's bookplates, she found a Victorian bookplate with these features that she sent to Kelly. He greatly simplified and modernized the original ornate design. The resulting bookplate, printed offset, "is perfect for me."

. .

PATRICK COLEMAN
(ELECTED 2020)
Clem Haupers, designer; Gerald Lange, Bieler Press, printer, mid-1980s

"My then-wife, Peggy, commissioned this bookplate for me in the mid-1980s. She had a good sense of humor and asked Clem Haupers, a crusty and ribald aging artist, to design an erotic bookplate. Clem is an important Minnesota artist who started the longest running annual art show in the state and ran the WPA art project here. Peggy told him about a few of my interests such as canoeing, wilderness and tall thin women (which was a joke because she was neither) and he worked those into the design. He added a typeface that he invented just for my bookplate which he laughingly called 'pecka.' Gerald Lange, Bieler Press, made a plate from the design and printed the bookplate on several different kinds of handmade papers. I have not really been using the bookplates because they are not what anyone would consider appropriate for my more serious books."

. .

DANIEL COQUILLETTE
(ELECTED 2001)
Thomas Todd Co., designer and printer, ca. 1975

Coquillette's major collection of sixteenth- through eighteenth-century law books was donated to Boston College Law School, where it forms part of the Coquillette Rare Books Room, named in his honor. As a legal historian, he believes that our law students face an uncertain future where the lessons of history will be invaluable. His bookplate reproduces a sixteenth-century image of Justice unmasked (in civil law she is not blindfolded), drawn from a book in his collection. This offset lithographic plate by the famous Boston printing house Thomas Todd Co. appeared in *Bookplates of the Club of Odd Volumes*, edited by Thomas G. Boss (2010).

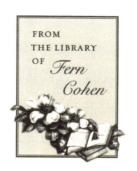

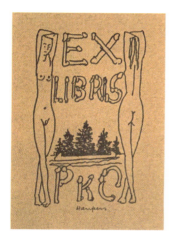

EX · LIBRIS
DANIEL · CO
QUILLETTE

BRUCE CRAWFORD (elected 2000) & MARY CRAWFORD (elected 2005)
Jerry Kelly (elected 1983), *designer, 2014*

The Crawford bookplates, designed by Jerry Kelly, feature a reproduction of an ink drawing by William Makepeace Thackeray, an author actively collected by the couple. Thackeray's wry humor is evident in the drawing: a rumpled fisherman has caught a tiny fish, his poor luck no doubt caused in part by his having just emptied the wine bottle that lies at his feet. The bookplate shown here was designed to celebrate the sixtieth birthday party given by Mary for Bruce at the Grolier Club. Other similar plates capture the family provenance of books in the Crawford library: those first acquired by Bruce and Mary, and those that passed through the libraries of Bruce's parents and grandparents.

. .

VICTORIA DAILEY (elected 1996)
Victoria Dailey, designer; Patrick Reagh, printer, 2013

During forty years of collecting, Dailey had never considered commissioning a bookplate, generally finding them pretentious, unwarranted, too large, or poorly designed. Suddenly, in 2013, she had the desire to insert a discrete bookplate into her French books on Parisian women and prostitution after the French Revolution in order to identify them as a collection. In 1975 her first acquisition was a dictionary of prostitutes at the Palais Royal (*Dictionnaire Anecdotique des Nymphes du Palais Royal*, 1826). The collection has since grown to over five hundred volumes and, inspired by a nineteenth-century example, she had Pat Reagh print her forestalled bookplate.

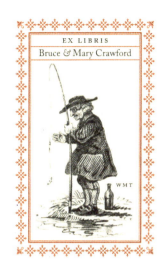

BIBLIOTHÈQUE
de
VICTORIA DAILEY
commencée en 1975

DAVID L. DiLAURA
(elected 2010)
David L. DiLaura, designer and printer, ca. 2006

DiLaura collects books on optics, vision, and light. His bookplate is based on one of the vignettes that appear in François Aguilon's *Opticorum Libri Sex* (1613), engraved by Philip Galle after drawings by Peter Paul Rubens. This particular image accompanies the first description in print of a light measurement (photometric) experiment, determining how the illuminating power varied with the distance from its source. To the careful reproduction of the image, DiLaura has added his name and the name of his collection: "Bibliotheca Opticoria," A Library Pertaining to Optics.

. .

MINDELL DUBANSKY
(elected 1990)
Mindell Dubansky, engraver;
Jerry Kelly (elected 1983), *printer, ca. 1979–1980*

Dubansky studied printmaking at Carnegie Mellon University, learning lithography, woodcut, and wood engraving. For a few years, beginning in the late 1970s, she produced a number of wood engravings inspired by book illustrations from the nineteenth century. Of the six bookplate wood engravings made during this period, three had flower motifs, a motif she has continued to work with in felt-making. Originally printing the bookplates herself from the blocks on a Vandercook press, when the time came to produce a bookplate for her book arts collection, she asked Jerry Kelly to print this plate on Japanese paper, with her name in red. In writing about this bookplate she notes, "I have always collected books and prints relating to wood engraving which I study and enjoy as part of my book arts library."

. .

LEON G. FINE
(elected 2016)
Leon G. Fine, designer; Printers Gallery, printer, ca. 1978

Fine designed the bookplate to bring together his collecting interests in medical history and in fine printing, using the existing type, image, and border in the possession of the printer. Hence it includes both the caduceus and a William Morris–style border.

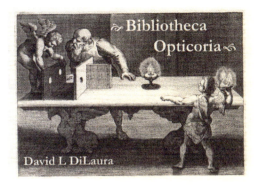

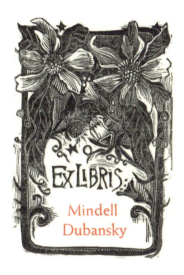
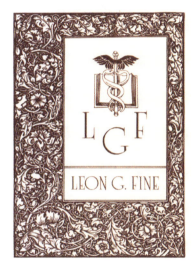

EUGENE S. FLAMM
(ELECTED 1985)
Abe Lerner (MEMBER 1974–2002), *designer;*
Jerry Kelly (ELECTED 1983), *printer, ca. 1990*

This bookplate combines texts from 1700 BCE and 1543 CE with a central image reproducing a glyph for "brain" from the Edwin Smith Papyrus, the world's oldest known medical document – very appropriate for a neurosurgeon who collects books in his specialty. Flamm translates "Vivitur Ingenio Caetera Mortis Erunt" as "Genius survives, all else perishes"; the quotation comes from the tombstone with the skeletal figure in Vesalius's *De Humani Corporis Fabrica* (1543).

. .

TOM L. FREUDENHEIM
(ELECTED 2017)
Corina Fletcher, designer;
Ralph J. Salerno, Keller Bros. & Miller, Inc., printer, 2005

"Among my various collections are bookplates and pop-up (or moveable) books. The bookplate interest comes from my father, who had collected a few early British ones while a young man in Berlin; those were always hanging on our walls when I was growing up, so they were part of my visual vocabulary. Moreover, because of their size I could purchase bookplates and bring them into the house unseen by my wife, thereby mitigating her anxiety about the never-ending expansion of my various accumulations. So I decided to combine two of my interests and commission a pop-up bookplate. I asked the designer to include: my name, my Hebrew initials, and my 'adopted' motto. I pinched the motto (*'Non habere, sed esse'*) from Tycho Brahe (1546–1601), the influential Danish astronomer, because it expresses ironies about me: my non-scientific interests, and the fact that I am a packrat who loves and lives with many *things*. I requested a design that I could assemble by myself with no glue (only folding), printed on one sheet (to save cost). Cutting the die was the costly part! (The misspelling – it's actually *'non haberi'* – is my error, not the designer's or printer's.) British graphic artist Corina Fletcher has worked on many 3-D designs of note, including some of the best-known pop-up books, as well as calendars and cards for the RSA."

EX LIBRIS

EUGENE SOMER FLAMM

MILTON McC. GATCH
(ELECTED 1989)
Martino Mardersteig, Stamperia Valdonega, designer and printer, 1996

The drawing of a running horse is by Jack B. Yeats, who added it when inscribing a copy of *A Lament for Art O'Leary: Translated from the Irish by Frank O'Connor, With Illustrations by Jack B. Yeats* (Cuala Press, 1940), which was in Gatch's collection of books by members of the Yeats family.

· ·

BASIE BALES GITLIN
(ELECTED 2014)
Richard Rose, designer; Canelli Printing, printer, 2010

A gift from his parents to celebrate Gitlin's college graduation, this book label holds many happy associations. Its designer was a favorite professor at Yale, the letterpress printer and graphic artist Richard Rose. Rose sought to create a label at once simple and elegant, fresh and traditional, that would reflect Gitlin's fondness for master engravers of letters such as Reynolds Stone, Leo Wyatt, and Stephen Harvard: "I think he very much succeeded!"

· ·

DAVID R. GODINE
(ELECTED 1971)
John Kristensen, Firefly Press, designer and printer, 2012

Not satisfied with having just one, the publisher has commissioned and created multiple bookplates. Along with a "personal bookplate" by Leo Wyatt, there are plates to mark particular subjects and types of books – designed and printed by Roland Hoover, by John Kristensen, and by David Godine himself. This one, for a Bruce Rogers collection, is his favorite. In each case, the intention has been to emphasize the objects themselves over the collector. Godine's bookplates are "fully constructed as an excessive and perhaps demented approach to the bookplate convention." He plans "to continue on this deluded path . . . [as his] collections expand," recalling "the immortal words of William Blake: 'The road of excess leads to the palace of wisdom.'"

EX LIBRIS
Milton McC. Gatch

ROBIN HALWAS
(elected 1990)
Leonard Baskin (member 1967–1976), *designer;*
Stellar Press, *printer, ca. 1983*

Halwas's bookplate reproduces a drawing by Leonard Baskin, executed ca. 1983. It was initially printed in two sizes on Strathmore paper, which varied in color. Baskin's original drawing for the plate was lost when the Stellar Press closed, but Halwas still holds two variant designs. This lithograph was reproduced in James P. Keenan and Jacqueline E. Davis's *American Artists of the Bookplate, 1970–1990* (1990).

. .

SUSAN HANES
(elected 2015)
Rhiannon Alpers, designer; Gazelle and Goat Press, printer, 2005

Taking advantage of digital technology, Hanes's bookplate is printed letterpress from polymer plates. Hanes is a Wilkie Collins enthusiast and collector, and the Victorian novelist's monogram inspired the design. Thinking about its creation, Hanes notes, "It was serendipitous that my initials have one straight-lined letter and one that curves, just as Collins's initials do. Thus, Alpers was able to curve the 'S' of my first name through the 'H' of my surname, just as the 'C' curves through the 'W' in Collins's monogram." Both monograms are completed with a quill arching through the letters.

. .

EARLE HAVENS
(elected 2006)
Scott Vile (member 1999–2012), *Ascensius Press, designer and printer, 2009*

Considering his bookplate, Havens writes, "This bookplate echoes a tradition of Renaissance portraiture marking both the age of the sitter and the year of production. I have always felt that one's library constitutes a kind of self-portrait. The Latin motto, sometimes attributed to Thomas Aquinas – 'fear the man of one book' – is ludic, exercising many, from Lope de Vega and Samuel Butler, down to Robert Southey." This bookplate is produced by offset lithography.

E libris

·

EARLE
ASHCROFT
HAVENS

·

Ætatis suæ
xxxviii / mmix

·

Hominem
unius libri
timeo

JOHN NEAL HOOVER
(ELECTED 2003)
John Neal Hoover and Tim Alton, designers and printers, 2002

Originally used as an advertisement for an early twentieth century planned suburban neighborhood, this image of Hoover's century-old house now appears on his bookplate. The design is inspired by the many bookish guests he has hosted: "A house appearing on a bookplate is an age-old tradition for just that reason – it represents an inviting shelter for books and reader alike." Hoover also has a smaller bookplate designed in the contemporary style. Both bookplates are used interchangeably; which book is matched with which bookplate depends upon his mood at the time.

. .

JERRY KELLY
(ELECTED 1983)
Jerry Kelly, designer; Three Star Offset, printer, 2019

"I thought I would never have a personal bookplate. I have made many bookplates for others, and I certainly have no problem with that, but as for myself, I feel that no design would go well with every type of book in my collection, and I have no great pride of ownership, so I thought I would just go without. I suppose I could have taken the route of my good friend David Godine and make different bookplates for different categories in my collections, but I decided not to make even one – until, after decades of enforcing this self-imposed restriction, I finally gave in a few years ago and made a bookplate for myself. The bookplate I designed is rather traditional (symmetrical, with a border), so I use it almost exclusively for older books. And I almost always mount it only in books which already have someone else's bookplate, so the book is already 'defaced' before I added my bookplate. Fittingly, the typeface is one I designed (actually the first type I designed): Rilke."

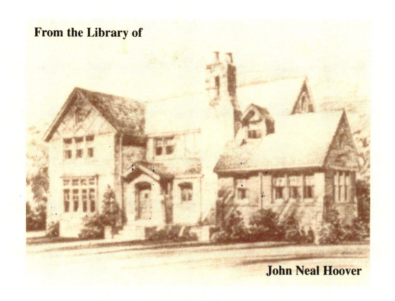

PETER RUTLEDGE KOCH
(elected 2000)
Peter Rutledge Koch, designer and printer, 2008

The device that has become both Koch's printer's mark and personal bookplate had its origin in Johann Daniel Mylius's *Anatomia Auri, sive Tyrocinium Medico-Chymicum*, printed in 1628. The graphic image there depicted of the dragon with its tail in its mouth (*ouroborous* οὐροβόρος) is of ancient Greco-Egyptian origin symbolizing the eternal and cyclical (creation/destruction) nature of being and matter – and in alchemy, the proto-science of chemistry, it symbolized the Black Stone or ur-matter from which all formed matter evolves (akin to lead and hence the name of Koch's first imprint, Black Stone Press). "How could I resist?" he writes.

. .

MICHAEL C. LANG
(elected 1978)
Michael C. Lang, designer and artist;
Jerry Kelly (elected 1983), *lettering & printer, 2005*

The bookplate shows a triskelion imposed on a stylized classical wax tablet. The triskelion or triskele is an extremely early symbol originating in the Neolithic period (ca. 3200 BCE), and was adopted in many cultures thereafter. Among its various meanings, it can denote constant forward movement. As in a Renaissance impresa, the design seeks to present a graphic representation of the motto, composed in ancient Greek, "I am ever learning."

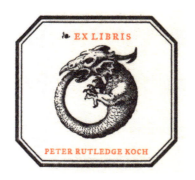

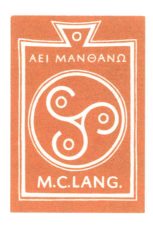

EDMUND L. LINCOLN
(ELECTED 1975)
Leo Wyatt, designer; Thomas Todd Co., printer, 1977

All did not go smoothly in the making of Lincoln's bookplate, an engagement present from his father-in-law, Peter Wick, a fellow Grolier Club member. Wick thought that in the original wood engraving the "L" in Lincoln looked like an "S," and that the middle initial "L" looked like a "C." A hard ink was used to ameliorate these problems, but a shadow was still visible on early impressions printed intaglio on the soft paper specified. Ultimately, Larry Webster of the Thomas Todd Co. in Boston produced the plates satisfactorily on a different paper by offset lithography." Lincoln has been very selective about the books in which he has placed the bookplate. In cases where a volume has marbled endpapers, he chooses which of the three color variants best matches the marbling.

. .

JON A. LINDSETH
(ELECTED 1992)
Jerry Kelly (ELECTED 1983), *designer; Three Star Offset, printer, 2021*

Made for Lindseth's Brontë collection, this bookplate features the arms of Frances Mary Richardson Currer and the eponym of 'Currer Bell,' the pseudonym of Charlotte Brontë. "One of Charlotte Brontë's earliest employments was as governess at an estate next to the Currer property. Charlotte possibly had interface with Ms. Currer as both had an interest in Mechanics' Institutes. In *Jane Eyre* (1847), she writes: 'I returned to my book – Bewick's *History of British Birds.*' I have in my collection the edition referred to (Newcastle, 1797) with the Currer's bookplate. Currer's bookplate is also present in the 1666 edition of Aesop's *Fables,* illustrated by Francis Barlow. I learned about the availability of this book as Bernard Quaritch had it for sale. They cited an article in the *Guardian* of 25 February 2015 by Alison Flood. (The actual Brontë family copy of Bewick's *History of British Birds* will be at the Brontë Parsonage at Haworth as part of the Honresfield Library.)"

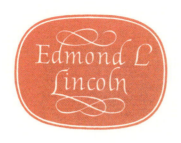

KENNETH JAY LINSNER
(ELECTED 2019)
Morgan & Morgan, printer, 1978

"While I collect books and manuscripts with an emphasis on art history and the fine and decorative arts, I also collect Asian art. The plate shows that influence and it is particularly suited to books in my Asian art reference library and is striking in my balance of my collection. The image was taken from a Chinese woodcut found in *The Imperial Edicts, Illustrated* of 1861 (Spencer Collection, New York Public Library), where it is titled 'A Scholar at Home.' For accuracy it should be noted that my plate exists in *two* colorways, black on white and red on white."

· ·

ROBERT LOPER
(ELECTED 2005)
Monica Incisa della Rocchetta, designer, 2000

Loper likes to think of this bookplate as "a portrait of myself, having long been reproached for always having my nose in a book. If the hidden face makes me seem enigmatic, so much the better." He commissioned the design from his friend Monica Incisa della Rocchetta, an Italian artist who excels at line drawings.

KENNETH JAY LINSNER

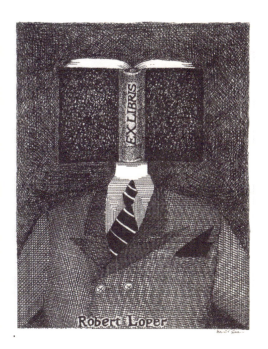

ANDREW T. NADELL
(ELECTED 1980)
Bruce Washbish, Anchor and Acorn Press, printer, ca. 1985

"This finely engraved 'N' was printed by the bookseller and publisher W. Owen as an initial in *A Vindication of the Royal College of Physicians* (1753) by Sir William Browne (1692–1774), who occupied several high offices in the Royal College of Physicians. I first saw this initial while browsing the stock of the London bookseller F. E. Whitehart in the 1970s, early in my book collecting career, and immediately realized that the 'N' had a future as my bookplate. The subject of this book, relating to the ethics and politics of the English medical profession, was perfect for my then-current collecting focus, medicine as a profession. It is housed in a signed Sangorski and Sutcliffe binding. The symbols on the left and right borders illustrate areas of study undertaken by contemporary university-educated physicians, including medicine, letters, the classics (Horace's *Satires*, Cicero's *Orations*) and the Renaissance (Copernicus's heliocentrism). In the center are four shelves of books, with both spines and fore-edges facing out. This bookplate was first printed in two sizes. I has since added a smaller third size, and I continue to use them in my collection, now focused more broadly on the professions and trades beyond medicine."

. .

ALEXANDER NEUBAUER
(ELECTED 2006)
Jerry Kelly (ELECTED 1983), *designer and printer, 2010*

Commissioned to accompany his James Joyce collection, Neubauer's bookplate is intended to embody a modern/early twentieth century style. Additionally, reflecting Joyce's *Ulysses* and his first name, the plate is designed to incorporate an echo of the Greek blue-and-white flag. This bookplate is printed by offset lithography.

ANDREW THOMAS NADELL, M.D.

ALEXANDER
NEUBAUER

ROBERT McCRACKEN PECK
(ELECTED 2002)
Richard E. Bishop, designer, 1972

When Peck was an undergraduate at college, he became very interested in bookplates and started a collection of those relating to his two passions, natural history and exploration. Since he did not have a bookplate of his own, he approached the sportsman and waterfowl artist Richard E. Bishop, a longtime family friend, to ask if he would draw one. Although Bishop was 85 at the time, and no longer making the etchings for which he is so well known, he sent Peck a pen-and-ink drawing showing Peck holding a book, while dozing in an armchair in front of the family's summer fishing cabin's fireplace, with a small flock of Canada geese emerging from the smoke as if in a dream. Peck still has the original drawing. Bishop, who designed many bookplates at the height of his career, was the artist-author of three books: *Bishop's Birds* (1936), *Bishop's Wildfowl* (1948), and *Prairie Wings* (1962). He was also the artist for one of the first US Federal Duck Stamps, officially known as the Migratory Bird Hunting Stamps (1936–37).

· ·

JEAN R. PERRETTE
(ELECTED 1994)
Patrick Maugard, designer and printer, ca. 1980s–1990s

Perrette's bookplate is an evocation of the Battle of St. Cast, which occurred on September 11, 1758. In this rendering, the British fleet is shown protecting itself in the bay of St. Cast, as it heads to land to re-embark British troops that are under fire by the French. On the right, Perrette's family property, built in the 1880s, is depicted.

· ·

SARAH PETER
(ELECTED 1998)
Sarah Peter, designer; Jerry Kelly (ELECTED 1983), *printer, 2009*

Printed with black ink on Mohawk paper, Peter's bookplate adorns the books in her Gentlewoman's Library, a counter to the classic Gentleman's Library. All the works in this collection were written by women, and the text on her bookplate reflects this: "Corpus Scriptorum Feminarium," or "A Women Authors Collection." The image on the bookplate is Peter's self-portrait.

SARAH PETER

Corpus Scriptorum
Feminarium

ROBERT J. RUBEN
(ELECTED 1990)
Robert J. Ruben, designer, 1988

This bookplate documents abbreviations representing Ruben's favorite aspects of life, including his children's and wife's initials, WSTS (Westinghouse Science Talent Search Award) and NIDOCD, which recalls the key role he had in establishing the National Institute on Deafness and Other Communication Disorders. The spiral alludes to the cochlea (hearing) and a diagram of the larynx (speech), which refers to his medical professional motto, "The Stone the builders rejected became the cornerstone" (Isaiah). Finally, the fish represents his favorite avocation – fishing. This bookplate was printed letterpress.

. .

MARK SAMUELS LASNER
(ELECTED 1989)
Sebastian Carter, designer, 1986

Mark Samuels Lasner's initial bookplate reproduced Dante Gabriel Rossetti's frontispiece for his sister Christina's 1862 volume, *Goblin Market and Other Poems*. While the design was appropriate for a collector of Victorian literature with a love of wombats, the plate itself proved too large to be placed into books that already possessed another bookplate. Sebastian Carter produced this calligraphic "label" in a much smaller size also suitable for letterhead and calling cards. After a brief period of obsessively pasting bookplates into books, Samuels Lasner mislaid the box of plates for a time and hasn't used them for the last twenty years.

HENRI SCHILLER
(ELECTED 1977)
Louis Boursier, designer; École Estienne, printer, 2012

Henri Schiller has devoted sixty years to assembling a library of manuscripts, printed books, and autographs. The idea that it needed an ex-libris arose naturally, with the thought that a bookplate, affixed to each volume, carries meaning long after the books are dispersed. A first attempt was made in 1997, but the process ended up taking fifteen years. It was Christopher de Hamel (ELECTED 1988) who cleverly pointed out that the monogram "HS" corresponds both to the name "Henri Schiller" and to "Homer–Shakespeare." Over time, the design went from a simple mark of ownership with Schiller's name or initials to a more elaborate image that explains the meaning of the collection and identifies the collector associated with it. While visiting the Metropolitan Museum of Art, Schiller admired a third-century marble sarcophagus with a dedicatory inscription on the lid flanked by two reliefs. This inspired the final design of his bookplate: his name in a central cartouche, with the figures of Homer at left and Shakespeare on the right. By 2010, he had selected four possible prototypes dating back to antiquity. Schiller chose what is thought to be the oldest, a bust of the Modena from the fourth century BCE. For Shakespeare, Schiller chose the Droeshout engraving from the First Folio. The lettering of the inscription was derived from fourth-century CE. Roman square capitals found in the Vergilius Augusteus manuscript held by the Vatican Library. Schiller worked with designers Gérard Desquand and Jean-Luc Seigneur and chose the design submitted by Louis Boursier, a pupil of Desquand. The figures of Homer and Shakespeare reached their final form in 2012: Homer is depicted full-face, his eyes white and smooth, allying nobility with the archaism of the Modena bust; Shakespeare looks directly into the viewer's eyes. The paper, selected from samples prepared by Christopher De Hamel, was Pop'Set Ivory made by Antalis. Two thousand bookplates were made at the presses of the École Estienne. Schiller's library is built slowly, with knowledge and ambition, every book chosen and placed with care. His bookplate is in every regard a reflection of this collection, revealing in a single image its intellectual foundation. From now on, Schiller's library, which is gradually reaching its full ambition, includes a mark of ownership that will endure for centuries, for as long as the books themselves survive. Unique among collectors, Schiller described in detail the creation of his bookplate in a privately printed pamphlet, *The Making of an Ex-libris* – from which this description is a synopsis translated from French into English.

JUSTIN G. SCHILLER
(ELECTED 1982)
Maurice Sendak (MEMBER 1973–1978), *designer;*
Jack Golden (MEMBER 1975–1988), *printer, 1982*

In 1972, Schiller commissioned the illustrator-author Maurice Sendak to produce a personalized bookplate. The resulting drawing proved too large and detailed for its intended purpose. (It did, however, include a caricature of the collector, in the form of a chubby waistcoat-wearing bear.) Realizing that a smaller-size work was needed, he chose one of four *Wild Things* images Sendak had created years earlier for *The Times* of London – a design also used for Schiller's personal stationery and as the logo for his second company, Battledore Ltd. Another Grolier Club member, Jack Golden, provided the lettering and printed the bookplate in 1982.

· ·

CAROLINE F. SCHIMMEL
(ELECTED 1979)
Will Carter, Rampant Lion Press, designer and printer, ca. 1980

This sliver of a book label was made to be subtle and with the goal to be small enough to be the single identifier of a collection that included miniature books. Schimmel's husband Stuart (also a member of the Grolier Club, 1961–2013) had a matching label, printed in five or six colors; he would spend hours pondering which color looked best in a particular book, but she wanted only olive to match her eyes. These labels, designed by their Cambridge friend Will Carter, were intended to be used for stationery for the couple's homes in New York and London.

Caroline F. Schimmel

JANE RODGERS SIEGEL
(ELECTED 1996)
Richard Wagener, designer and printer, 2007

After her mother passed away in 2006, Siegel decided to fulfill a longstanding ambition to have a bookplate made. Siegel took inspiration from a stone bridge in Pennypack Park, Philadelphia, where her family would go walking during her childhood. It is recognized as the oldest stone bridge in the United States, as it was built in 1697 so William Penn could travel between Philadelphia and his estate in Delaware. Siegel has a photograph of her parents around the time of their wedding with the bridge in the background. She likes to think of the plate as a bit of a memorial for them. This bookplate is a wood engraving.

. .

JONATHAN STONE
(ELECTED 2015)
Russell Maret (MEMBER 2013–2020), *designer and printer, 2013*

Considering his appreciation of Maret's skills and his letterpress bookplate, Stone writes, "Russell's books are at once austere and playful, serious yet quirky. His deep knowledge and abiding love of letter forms riff with a humor that peeks through in his ornaments. These qualities distinguish his voice, his line, and his eye; they are appreciable in the bookplate he designed for me. I love the mesmerizing curves of the ornaments as they dance around the text. Russell's touch as an artist and printer is unmistakable here."

. .

GARY STRONG
(ELECTED 1995)
Joe D'Ambrosio, designer and printer, 1999

Strong commissioned this bookplate from D'Ambrosio after leaving his post as California State Librarian and becoming the director of the Queens Borough Public Library (he later moved on to become University Librarian at UCLA). D'Ambrosio derived the "Livre d'Strong" from the French "Livre d'Art" using an outline as opposed to bold black letters for his first name in lower case. The bug in the lower section of the ellipse is a play on the letter "Q" for Queens Library, making it a living, breathing design element. This bookplate is computer-generated, apart from the bug, and is printed letterpress on archival paper from a plate.

EX LIBRIS JANE RODGERS SIEGEL

DAVID J. SUPINO
(ELECTED 1992)
David J. Supino, designer, ca. 1999

Supino designed this bookplate long before he donated his entire Henry James collection to Yale – some 1,300 volumes. He wanted something that was small and unobtrusive, that would serve as a record of provenance. Curiously, he never actually used the bookplate because something in the back of his mind seemed to say it might deface the book. The roughly 1,000 copies printed were given to Yale as well – "so a dealer might not salt his James book!" Supino recalls that once in the 1980s on a visit to Quaritch, a member of the staff opened a drawer and showed him a packet of unused bookplates of the novelist Anthony Trollope.

. .

SUSAN JAFFE TANE
(ELECTED 2006)
Carla DeMello, designer, 2006

Tane's bookplates, depicting three of her collections, showcase Poe's "Raven," Melville's "Whale," and the "Presidential Eagle." During her 2006 "Nevermore" exhibition at Cornell University Library, their designer, Carla DeMello, created the bookplates as the library's thank you gift to commemorate Tane's loan exhibitions.

. .

G. THOMAS TANSELLE
(ELECTED 1969)
James Hayes, designer; Dupli-Graphic Processors, printer, 1970

"I was introduced to the work of the Chicago calligrapher James Hayes (1907–1994) in the late 1960s by Matt Lowman, who was then a staff member at the Newberry Library. He showed me his Hayes bookplate during one of my extended periods of residence there in connection with the Northwestern-Newberry project for editing Melville. Hayes appealed to me not only as a renowned calligrapher but also as an accomplished collector of medieval manuscript leaves. The bookplate is printed by offset lithography in maroon ink on ivory wove Strathmore writing stock."

JOHN VAN SICKLE
(ELECTED 1989)
Abe Lerner (MEMBER 1974–2002), *designer, 1990*

Upon joining the Grolier Club, Van Sickle was counseled by fellow member Fred Schreiber to enlist Abe Lerner to design his bookplate. This bookplate's three components take inspiration from Virgil. "Sicelides Musae," or Muses of Sicily, is the opening of Virgil's "messianic eclogue" – the focus of Van Sickle's doctoral study and a pun on his name (Dutch: "of Siclen"). "Amor Maro Roma," or Love Virgil Rome, is an anagram of passion for both poet and place. The central woodcut features Virgil's themes of bucolic music, georgic labor, and civic and heroic scenery, and it serves as the frontispiece for the *Georgics*, translated by Daniello (Venice, 1549).

. .

THOMAS D. WHITRIDGE
(ELECTED 1979)
Thomas Whitridge, designer and printer, 2021

"This was created a year ago; it was self-designed and printed digitally (20 up) on Mohawk Superfine white eggshell text which then had an adhesive applied, making the bookplates 'pressure sensitive' (as it is known in the trade): no more paste-pot!; and 'kiss' die-cut so that each label on the sheet is independent. The guiding principle of the 'design' is 'LSD' (Lovely Simple Design)."

. .

SIMON WILSON
(ELECTED 2000)
Susan Groom, designer, 1964

Wilson had already discovered Aubrey Beardsley when he commissioned this bookplate in 1964. Groom, a friend, responded with a lively and autobiographical pastiche. The main figure is Wilson, and the female figure is Groom. It was printed by line block, the method that Beardsley worked with to such effect. Wilson has used it sparingly, placing it mostly on the inside of box lids, on the outside of slipcases, or tipped in loose.

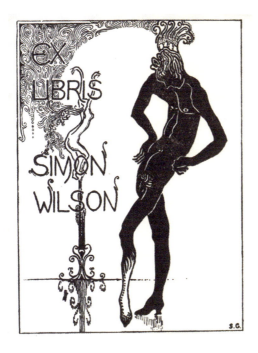

CHARLES B. WOOD
(ELECTED 1972)

Scott Vile (MEMBER 1999–2012), *Ascensius Press, designer and printer, 2009–2010*

For his extensive collection on fly-fishing for Atlantic salmon, Wood had this bookplate made by Scott Vile, with the calligraphic initials drawn by an artist whose name he no longer can recall. Many of the items were described in detail in his catalogue, *Bibliotheca Salmo Salar: A Selection of Rare Books, Manuscripts, Journals, Diaries, Photograph Albums, & Ephemera on the Subject of Atlantic Salmon Fishing from the Collection of Charles B. Wood III*, published by fellow member David R. Godine in 2017.

. .

THOMAS EDWIN WOODHOUSE
(ELECTED 1997)

Stan Washburn, designer and printer, 2000

Woodhouse has had a long love of horses, and he wanted to feature one on his bookplate. The quotation surrounding this image is from Job 39: 19, 21, 22, and 25. For this commission Woodhouse turned to his longtime friend Stan Washburn of Berkeley, California. Washburn's illustrations have appeared in several works published by the Arion Press.

. .

VIC ZOSCHAK, JR.
(ELECTED 2007)

Vic Zoschak, Jr., designer, ca. 1987

As a beginning collector of Dickens, Zoschak thought he might make his books "more his own" by commissioning a bookplate modeled after the one used by the Victorian novelist. He is apparently the first Dickensian to do so. Given the fact that Dickens himself "appropriated" the armorial lion, Zoschak is, in effect, following in his footsteps.

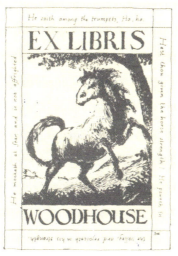

VIT ZOSTHAK JR.

NOTES

1. *Transactions of The Grolier Club of the City of New York from February Eighteen Hundred and Ninety-four to July Eighteen Hundred and Ninety-nine. Part III* (New York: Grolier Club, 1899), 82. See also George Ong and Eric J. Holzenberg, *For Jean Grolier & His Friends: 125 Years of Grolier Club Exhibitions & Publications, 1884–2019* (New York: Grolier Club, 2019), 38–39, 302. Allen expanded his "classified checklist" into *American Book-Plates: A Guide to Their Study*, published in 1895 by George Bell and Sons, London, in their "ex libris" series of books about books.

2. For an important recent example of bookplate studies presented within an interdisciplinary academic framework, see Olivia Armandroff, "William Fowler Hopson and the Art of the Personalized Bookplate at the Turn of the Twentieth Century," *Winterthur Portfolio: A Journal of American Material Culture* 54, no. 1 (Spring 2020): 65–107.

3. Stephen Greenblatt, *Renaissance Self-Fashioning: From More to Shakespeare* (Chicago: University of Chicago Press, 1980), 2, 3–4.

4. Ibid., 5.

5. Jan R. Veenstra, "The New Historicism of Stephen Greenblatt: On Poetics of Culture and the Interpretation of Shakespeare," *History and Theory* 34, no. 3 (October 1995): 197–198.

6. Bookplate of Bell's Circulating Library, Philadelphia, Rare Book Department, Free Library of Philadelphia.

7. Frederick Spenceley, "Spenceley Book Plates," promotional pamphlet, Grolier Club Bookplate Collection.

8. Ibid.

9. See Edwin Davis French, proofs of bookplates for Mary Emma Plummer and John Page Woodbury and bookplate for Edward Duff Balken, Grolier Club Bookplate Collection.

10. Jacob Solis-Cohen to L. H. Price, undated, Rare Book Department, Free Library of Philadelphia.

11. Wolfgang Iser, *The Act of Reading: A Theory of Aesthetic Response* (Baltimore, MD: Johns Hopkins University Press, 1978), x.

12. For more on this important collection, see the University of Delaware Library's finding aid for the Alice Dunbar-Nelson papers, accessed December 29, 2021, https://library.udel.edu/special/findaids/view?docId=ead/mss0113.xml

13. Biographical details taken from the American Antiquarian Society's guide to the Dorothy Sturgis Harding manuscript collection, accessed January 8, 2022, www.americanantiquarian.org/Findingaids/dorothy_sturgis_harding.pdf.

14. For examples of Harding's other works, see *The Bookplates of Dorothy Sturgis Harding, with Text by C. Howard Walker* (Boston: The Graphic Arts Company, 1920).

15. Eleanor Roosevelt to Dorothy Sturgis Harding, July 1, 1933, Dorothy Sturgis Harding Papers, American Antiquarian Society.

16. Ibid.

17. Dorothy Sturgis Harding to Eleanor Roosevelt, undated draft letter, Dorothy Sturgis Harding Papers, American Antiquarian Society.

18. Telegram from Eleanor Roosevelt to Dorothy Sturgis Harding, December 29, 1934, Dorothy Sturgis Harding Papers, American Antiquarian Society. Note that, in the image, the year "1935" appears written in pencil on the telegram. This seems to be a dating error by an archivist. Other correspondence suggests that the White House meeting was held in late 1934, and indeed December 31 was a Monday in 1934 and a Tuesday in 1935.

19. Dorothy Sturgis Harding to Eleanor Roosevelt, January 8, 1935, Papers of Eleanor Roosevelt, Franklin D. Roosevelt Library, Hyde Park, New York.

20. Eleanor Roosevelt to Dorothy Sturgis Harding, January 11, 1935, Dorothy Sturgis Harding Papers, American Antiquarian Society.

21. Dorothy Sturgis Harding to Eleanor Roosevelt, March 21, 1935, Papers of Eleanor Roosevelt, Franklin D. Roosevelt Library.

22. Bill from Forbes Lithograph Manufacturing Company to Mrs. Lester Harding,

April 17, 1935, Dorothy Sturgis Harding Papers, American Antiquarian Society.

23. Eleanor Roosevelt to Dorothy Sturgis Harding, April 26, 1935, Dorothy Sturgis Harding Papers, American Antiquarian Society.

24. Dorothy Sturgis Harding to Eleanor Roosevelt, March 21, 1935, Papers of Eleanor Roosevelt, Franklin D. Roosevelt Library.

25. Eleanor Roosevelt to Dorothy Sturgis Harding, March 27, 1935, Dorothy Sturgis Harding Papers, American Antiquarian Society.

26. Eleanor Roosevelt to Dorothy Sturgis Harding, May 19, 1938, Dorothy Sturgis Harding Papers, American Antiquarian Society.

27. Dorothy Sturgis Harding to Eleanor Roosevelt (draft letter), June 7, 1958, Dorothy Sturgis Harding Papers, American Antiquarian Society.

28. Eleanor Roosevelt to Dorothy Sturgis Harding, June 12, 1958, Dorothy Sturgis Harding Papers, American Antiquarian Society.

29. Dorothy Sturgis Harding to Eleanor Roosevelt, draft letter, July 5, 1958, Dorothy Sturgis Harding Papers, American Antiquarian Society; Eleanor Roosevelt to Dorothy Sturgis Harding, July 11, 1958, Dorothy Sturgis Harding Papers, American Antiquarian Society.

30. See the finding aid for the Dorothy Sturgis Harding Papers, American Antiquarian Society, accessed December 31, 2021, www.americanantiquarian.org/Findingaids/dorothy_sturgis_harding.pdf.

31. Lawson A. Moyer to Eleanor Roosevelt, October 22, 1941, Dorothy Sturgis Harding Papers, American Antiquarian Society.

32. Ibid.

33. Ibid.

34. Eleanor Roosevelt to Dorothy Sturgis Harding, November 19, 1941, Dorothy Sturgis Harding Papers, American Antiquarian Society.

35. See the finding aid for the Dorothy Sturgis Harding Papers, American Antiquarian Society, www.americanantiquarian.org/Findingaids/dorothy_sturgis_harding.pdf.

36. The story of Harry Elkins Widener, A.S.W. Rosenbach, and Eleanor Elkins Widener is best told by Leslie A. Morris in "Harry Elkins Widener and A.S.W. Rosenbach: Of Books and Friendship," *Harvard Library Bulletin* 6, no. 4 (Winter 1995): 7–28. For more insights on Harry Elkins Widener and the Rosenbach's *Titanic* connections, listen to Episodes 5–8 of the Rosenbach Podcast, available at https://rosenbach.org/podcast/.

37. Walter Crane to Harry Elkins Widener, 1908, Houghton Library, Harvard University, https://iiif.lib.harvard.edu/manifests/view/drs:47093359$1i.

38. Walter Crane to Harry Elkins Widener, June 23, 1908, Houghton Library, Harvard University, https://iif.lib.harvard.edu/manifests/view/drs:47093359$1i.

39. Walter Crane to Harry Elkins Widener, December 24, 1908, Houghton Library, Harvard University, https://iiif.lib.harvard.edu/manifests/view/drs:47093359$1i.

40. Eleanor Elkins Widener to A.S.W. Rosenbach. [July? 1914], Rosenbach Company Archives, The Rosenbach, Philadelphia.

41. "An American 'Lycidas': Harry Widener's Bequest to Harvard," *Daily Telegraph*, June 5, 1912. The article was most likely written by A. Edward Newton; see note below.

42. A. Edward Newton, *The Amenities of Book-Collecting and Kindred Affections* (Boston: Atlantic Monthly Press, 1918), 352.

43. Ibid., 353.

44. Ibid., 355.

45. A. S. W. Rosenbach, *In Memoriam: Harry Elkins Widener* (Philadelphia: Privately printed, 1912).

46. A. S. W. Rosenbach, "Memoir: Harry Elkins Widener," in *A Catalogue of the Books and Manuscripts of Robert Louis Stevenson in the Library of the Late Harry Elkins Widener with a Memoir by A.S.W. Rosenbach* (Philadelphia: Privately printed, 1913), 11.

47. For one hundred illustrations by that many designers, see William E. Butler, *American Bookplates* (London: Primrose Hill Books, 2000). Two of the author's own bookplates are reproduced here (Figures 20 and 21).

48. Ibid., pp. 19–23.
49. "Bookplate" and "ex-libris" will be used interchangeably here, despite the English term "bookplate" being maligned as imprecise and potentially confused with book illustration, which is also often referred to as a plate. See W. J. Hardy, *Book-Plates* (London: Kegan Paul, Trench, Trübner & Co., Ltd, 1893), 5–6. In addition, according to Benoît Junod: "If referring to a bookplate as an object, it should be written 'ex-libris', as it is a composite of two non-English words . . . However, an increasing number of people use 'exlibris', influenced by German (in which this is correct, but takes a capital E!) but not by French where it is 'ex-libris' as in English." Benoît Junod, "Frequently Asked Questions," International Federation of Ex-libris Societies, accessed January 4, 2022, www.fisae.org/faq.html.
50. Bookplates may also appear on back covers or flyleaves, or they may be tipped in elsewhere within a book. For example, Keith Houston illustrates the bookplate on the first page of his text block, but his book makes no mention of the ex-libris otherwise. Keith Houston, *The Book: A Cover-to-Cover Exploration of the Most Powerful Object of Our Time* (New York: W. W. Norton & Company, 2016).
51. "[The bookplate] defaces the book [and] will detract from the book's value as it is (most often) considered a blemish." Denise Enck, "Bookplates: Various Types, Desirability & How They Affect Book Values," *Empty Mirror*, www.emptymirrorbooks.com/collecting/bookplates.
52. By comparison, some consider "attaching a bookplate to a book . . . a material act of appropriation." Carrie Griffin and Mary O'Connell, "Writing Textual Materiality: Charles Clark, His Books and His Bookplate Poem," in *Readings on Audience and Textual Materiality* (London: Pickering & Chatto, 2011), 86.
53. Beginning in the mid- to late nineteenth century, the bookplate became a cultural artifact worthy of study and, more crucially, collection. Societies sprang up to promote scholarship and exchange among bookplate enthusiasts. But for all the interest and admiration, the bookplate was the subject of much debate, and the bookplate collector was the subject of condemnation. Many early collectors removed historical bookplate specimens, often by steaming or soaking the plates off the covers of books. On occasion they ripped out leaves or removed entire covers. Even some libraries engaged in this practice, isolating and individually cataloging the bookplates removed from their library holdings. These collectors and librarians valued the bookplate *as such*, rather than in its context, attached to a specific copy of a specific title. With more recent interest in books as objects, the materiality of texts, and the histories of libraries or reading, etc., scholars now lack a significant body of evidence for book provenance. Any defacement or destruction of books is of course discouraged; however, these objectionable past practices still haunt bookplate collectors today. See, for example: "Booksellers and librarians should be particularly wary of the bookplate collector, who might wish to soak off the plates of books." Sidney E. Berger, *Rare Books and Special Collections* (Chicago: Neal-Schuman, 2014), 137.
54. Clara Therese Evans, *A Census of Bookplate Collections in Public, College and University Libraries in the United States (with Several Foreign References)* (Washington, DC: Bruin Press, 1938), 10.
55. "Warren Hiram Lowenhaupt Papers," Manuscripts and Archives, Yale University Library, accessed January 31, 2022, archives.yale.edu/repositories/12/resources/3159.
56. Warren Hiram Lowenhaupt, "The Pearson–Lowenhaupt Collection of English and American Bookplates," *Yale University Library Gazette* 30, no. 2 (1955): 49–59.
57. Various bookplate memberships and organizations are active worldwide, and these biennial congresses continue to this day. See, for example, "Bookplates by the Bay 2022, FISAE XXXIX Global Congress, September 11–18, 2022," accessed January 7, 2022, bookplate2022.org/.
58. Lowenhaupt, "Pearson–Lowenhaupt Collection," 59.
59. Lowenhaupt considered the quantity and variety of bookplates ideal for "competi-

tive collecting." Lowenhaupt, "Pearson–Lowenhaupt Collection," 58.
60. Ibid., 50. For the Linonian Society bookplate engraved by Amos Doolittle, which Pace received from Lowenhaupt, see box 386, Andrews Memorial Bookplate Collection of Irene D. Andrews Pace, Robert B. Haas Family Arts Library, Yale University.
61. James T. Babb to Warren Hiram Lowenhaupt, August 4, 1954, Warren Lowenhaupt Papers, Manuscripts and Archives, Yale University Library.
62. Lowenhaupt, "Pearson–Lowenhaupt Collection," 59, emphasis added.
63. Warren Hiram Lowenhaupt, "The Andrews Memorial Bookplate Collection of Irene D. Andrews Pace," *Yale University Library Gazette* 37, no. 4 (1963): 179.
64. For example, between January and August of 1932, Pace's collection grew by 7,000 items. A newspaper article from January of 1932 describes a talk given by Pace to the Geneva, Illinois, Woman's Club, and cites her collection as an estimated 35,000 bookplates. By August of that same year, another feature story estimates Andrews's collection to number 42,000. Marion Phillips, "Geneva Women Hear Talk on Book Plates: Mrs. Irene Andrews Shows Part of Valuable Collection of 35,000," unidentified newspaper, January 20, 1932; Ruth de Young, "Mrs. Andrews' Bookplates Total 42,000: Many Rare Treasures in Her Huge Collection," *Chicago Daily Tribune*, August 6, 1932.
65. Win Zwiers to Irene Andrews Pace, 1948, Andrews Memorial Bookplate Collection of Irene D. Andrews Pace, Robert B. Haas Family Arts Library, Yale University.
66. Lowenhaupt, "Andrews Memorial Bookplate Collection," 179.
67. Irene D. Andrews Pace, index card with annotations, April 2, 1954–September 26, 1961, Andrews Memorial Bookplate Collection of Irene D. Andrews Pace, Robert B. Haas Family Arts Library, Yale University.
68. Irene D. Andrews, *Owners of Books: The Dissipations of a Collector* (Washington, DC: Bruin Press, 1936), ix, emphasis in original.
69. Ibid.
70. Lowenhaupt, "Andrews Memorial Bookplate Collection," 180.
71. Ibid.
72. Ibid.
73. Irene D. Andrews Pace, sheet with mounted bookplate and annotations, undated, Andrews Memorial Bookplate Collection of Irene D. Andrews Pace, Robert B. Haas Family Arts Library, Yale University.
74. "U.S. Paradise to Austrian Painter: Noted Landscapist Loves Americans and All Their Ways Except Those in Parking Lots," *Los Angeles Times*, February 17, 1954.
75. Ernest Huber to Irene D. Andrews Pace, March 31, 1954, Andrews Memorial Bookplate Collection of Irene D. Andrews Pace, Robert B. Haas Family Arts Library, Yale University.
76. Lowenhaupt, "Andrews Memorial Bookplate Collection," 180–181.
77. Andrews, *Owners*, ix.
78. Scholarship that problematizes the nature of archives can be found in numerous disciplines from library science to literature as well as history, art history, and many more. See, for example, a recent reconsideration of the role of the death drive in Jacques Derrida's *Archive Fever*. Carolin Huang, "Dwelling on the 'anarchival': Archives as Indexes of Loss and Absence," *Archival Science* 20, no. 3 (September 2020): 263–277.
79. Andrews, *Owners*, 271.
80. Ernest Huber to Irene D. Andrews Pace, March 31, 1954, Andrews Memorial Bookplate Collection of Irene D. Andrews Pace, Robert B. Haas Family Arts Library, Yale University.
81. Werner Muensterberger, *Collecting: An Unruly Passion; Psychological Perspectives* (Princeton, NJ: Princeton University Press, 1994), 209.
82. Lowenhaupt, "Andrews Memorial Bookplate Collection," 181.

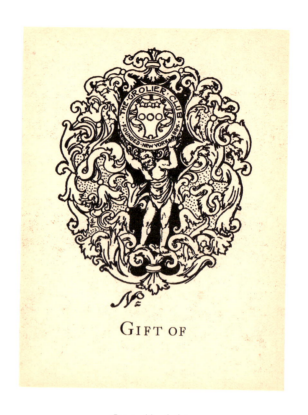

Original bookplate
of the Grolier Club designed by
George Wharton Edwards in 1889.

INDEX OF OWNERS, COLLECTORS, DESIGNERS & PRINTERS

Adler, Elmer, 58
Alderman, Muriel, 13
Allen, Charles Dexter, 8, 33
Alpers, Rhiannon, 124
Alton, Tim, 126
Altschul, Frank, 58
Altschul, Helen Lehman Goodhart, 58
Ames, Alexander Lawrence, 104
Anchor and Acorn Press, 134
Andreini, Joseph Manuel, 60
Andrews, William Loring, 60
Arellanes, Audrey Spencer, 36, 43
Ascensius Press, 124, 150
Babb, George Fletcher, 70
Baer, Carlyle Solomon, 36
Balken, Edward Duff, 16
Bareiss, Walter, 62
Barnhill, Georgia B., 104
Barrett, Clifton Walter, 62
Baselitz, Georg, 62
Baskin, Leonard, 82, 106, 124
Baskin, Lisa Ungar, 106
Bassett, Helen Wheeler, 36
Basso, Gianni, 110
Bayros, Franz von, 78
Beattie, Simon, 106
Bell's Circulating Library, 14
Berger, Andrew L., 106
Bieler Press, 114
Bienaimee, Suze, 108
Bird, Elisha Brown, 16, 36,
Bishop, Richard E., 136
Bixby, William Keeney, 60
Blumenthal, Joseph, 88
Bockstoce, John R., 108
Boehm, Nancy K., 108
Boss, Thomas G., 110
Boursier, Louis, 140
Brandenburg, Hilprand (of Biberach), 15
Braun, Wilson, 110

Brett, Simon, 106
Brewer, Augusta LaMotte, 17
Brodney, Leonard J., 82
Brown, Alfred Jerome, 64
Browne, Lord (of Madingley), 110
Butler, William E., 112
Byers, Reid, 112
Canelli Printing, 122
Carter, Sebastian, 138
Carter, Will, 110, 112, 142
Carver, Clifford Nickels, 35
Cave-Browne-Cave, Robert, 50
Chadwyck-Healey, Charles, 112
Cheney, Sheldon, 35
Chew, Beverly, 66
Clarke & Way, 70, 82
Clements, William L., 68
Club Bindery, 86
Cohen, Fern, 114
Coleman, Patrick, 114
Coquillette, Daniel, 114
Craig, Edward Gordon, 17
Cranach, Lucas, 15
Crane, Walter, 20, 27–30, 100
Crawford, Bruce, 116
Crawford, Mary, 116
Cummington Press, 76
Dailey, Victoria, 116
Daly, Augustin, 68
D'Ambrosio, Joe, 144
DeMello, Carla, 146
De Vinne, Theodore Low, 70
DiLaura, David L., 118
Doolittle, Amos, 47
Dubansky, Mindell, 118
Dunbar-Nelson, Alice, 20–21
Duncan, Harry, 76
Dupli-Graphic Processors, 146
Easy Hill Press, 84
École Estienne, 140

[157]

Edwards, George Wharton, 56
Elwell, Robert, 70
Eragny Press, 58
Fearing, Daniel B., 72
Fine, Leon G., 118
Fingesten, Michel, 53
Firefly Press, 110, 122
Flamm, Eugene S., 120
Fletcher, Corina, 120
Forbes Lithograph Manufacturing Co., 24
Fowler, Harry Alfred, 35
French, Edward Davis, 16, 56, 60, 66, 70
Freudenheim, Tom L., 120
Friedlaender, Helmut N., 72
Gatch, Milton McC., 122
Gazelle and Goat Press, 124
Gill, Eric, 78
Gitlin, Basie Bales, 122
Godine, David R., 122
Goff, Amelia Seabury, 74
Goff, Frederick Richmond, 74
Golden, Jack, 142
Goodhue, Bertram Grosvenor, 74
Goodspeed, Charles Eliot, 76
Gosling, Gianni Basso, 110
Grolier Club, 56
Groom, Susan, 148
Guillot, Silvain, 92
Hagstrom, Jack W. C., 76
Halwas, Robin, 124
Hamilton, Susan Kress, 108
Hanes, Susan, 124
Harding, Dorothy Sturgis, 22–27
Haupers, Clem, 114
Havens, Earle, 124
Hayes, James, 146
Hays, William R. A., 78
Hill, Sara B., 36
Hofer, Philip, 78
Hoover, John Neal, 126
Horgan, Stephen H., 8
Hornby, Charles St. John, 80
Huber, Ernest, 49, 51–52
Hyde, Donald, 80
Hyde, Mary, Viscountess Eccles, 80

Hyder, Darrell, 104
Keenan, James P. 36, 124
Keller Bros. & Miller, Inc., 120
Kelly, Jerry, 94, 114, 116, 118, 120, 126, 128, 130, 134, 136
Kelmscott Press, 98
Kent, Rockwell, 58
Koch, Peter Rutledge, 128
Koch, Rudolph, 78
Kredel, Fritz, 78
Kristensen, John, 110, 122
Landon, Richard, 82
Lang, Michael C., 128
Lange, Gerald, 114
Lerner, Abe, 82, 120, 148
Lewis, Arthur Allen, 96
Libanus Press, 106, 112
Lichtenstein, Richard C., 33
Lincoln, Edmund L., 130
Lindseth, Jon A., 130
Linsner, Kenneth Jay, 132
Loper, Robert, 132
Lowenhaupt, Warren Hiram, 46–47
Macdonald and Co., 84, 86
Macdonald, Arthur Nelson, 98
Macdonald, James, 86
MacDonald, Thoreau, 82
Mardersteig, Martino, 120
Maret, Russell, 144
Maugard, Patrick, 136
Mauran, James Eddy, 33
Mellon, Paul, 84
Merwin, Walter S., 84
Miranda, Artur Mário da Mota, 43
Monnetta, Orra Eugene, 36
Moran & Morgan, 132
Morgan, John Pierpont, 86
Morris, William, 19
Mosher, Thomas Bird, 88
Nadell, Andrew T., 134
Naumburg, Edward, 88
Neubauer, Alexander, 134
Newton, A. Edward, 90
Noll, Arthur H., 36
Olivetree Design, 104
Osgood, Charles Grosvenor, 90

Pace, Irene D. Andrews, 45–54
Peake, Andrew, 43
Peck, Robert McCracken, 136
Perrette, Jean R., 136
Peter, Sarah, 136
Pforzheimer, Walter, 92
Pforzheimer, Walter L., 92
Phineas Press, 108
Plummer, Mary Emma, 16
Pissarro, Esther, 58
Pissarro, Lucien, 58
Plummer, Mary Ellen, 16
Printers Gallery, 118
Pyle, Howard, 56
Pynson Printers, 58
Quinn, John, 19–20, 51
Rampant Lion Press, 110, 112, 142
Rathbun, Frank R., 88
Raymo, Robert R., 94
Reagh, Patrick, 116
Rhead, Louis J., 94
Rocchetta, Monica Incisa della, 132
Rogers, Bruce, 96
Roosevelt, Eleanor, 22–27
Rose, Richard, 122
Ruben, Robert J., 138
Salerno, Ralph J., 120
Samuels Lasner, Mark, 138
Scheurl, Christoph, 15
Schiller, Henri, 140
Schiller, Justin G., 142
Schimmel, Caroline F., 142
Schimmel, Stuart, 142
Schomburg, Arthur A., 21–22
Sendak, Maurice, 142
Seymour, Ralph Fletcher 51
Shorter, Clement K., 20
Siegel, Jane Rodgers, 144
Simon, Brigitte, 106
Skiff, Frederick W., 19
Smith, Richard Shirley, 112
Smith, Sidney Lawton, 72, 76, 90
Spectrum Graphics, 114
Spenceley, Frederick, 11, 15
Spenceley, Joseph Winfred, 58
Sperling, Philip, 96

Sperling, Sylvia, 96
Spiral Press, 88
Stamperia Valdonega, 120
Stellar Press, 124
Stock, Karl F., 43
Stone, Jonathan, 144
Stone, Reynolds, 70, 80
Strong, Gary, 144
Sulzberger, David, 17–19
Supino, David J., 146
Tane, Susan Jaffe, 146
Tanselle, G. Thomas, 146
Terry, Ellen, 17
Terry, Roderick, 98
Terry, Seth, 98
Thomas Todd Co., 114, 130
Three Star Offset, 126, 130
Tiffany and Co., 68
Turner, William McAllister, 49
Van Sickle, John, 148
Vile, Scott, 124, 150
Wagener, Richard, 144
Walker, Sir Emery, 98
Ward, Lynd, 49
Washbish, Bruce, 134
Washburn, Stan, 150
Watson, William J., 84
Watts, Schuyler, 100
Webb, Margaret Ely, 13, 17
Webb, Philip, 80
Wheeler, Monroe, 100
Whiting, W. D., 56
Whitmore, William Henry, y33
Whittridge, Thomas D., 148
Widener, Harry Elkins, 27–30, 100
Wilcox, John Angel James, 100
Williams, Paul Wightman, 76
Wilson, Simon, 148
Wood, Charles B., 150
Woodbury, John Page. 16
Woodhouse, Thomas Edwin, 150
Wyatt, Leo, 112, 130
Yeats, Jack Butler, 20
Young, Pauline, 20
Zoschak, Vic, 150
Zwiers, Wim, 48

*Set in
Caslon types. Printed in the Czech Republic
by PB Tisk. Design & typography
by Jerry Kelly.*

∴